BLUE RIDGE PARKWAY
Wonder and Light

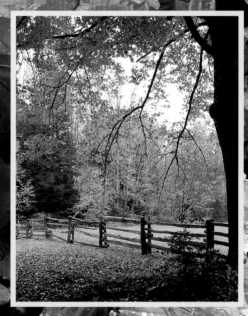

PHOTOGRAPHY BY
JERRY D. GREER IAN J. PLANT

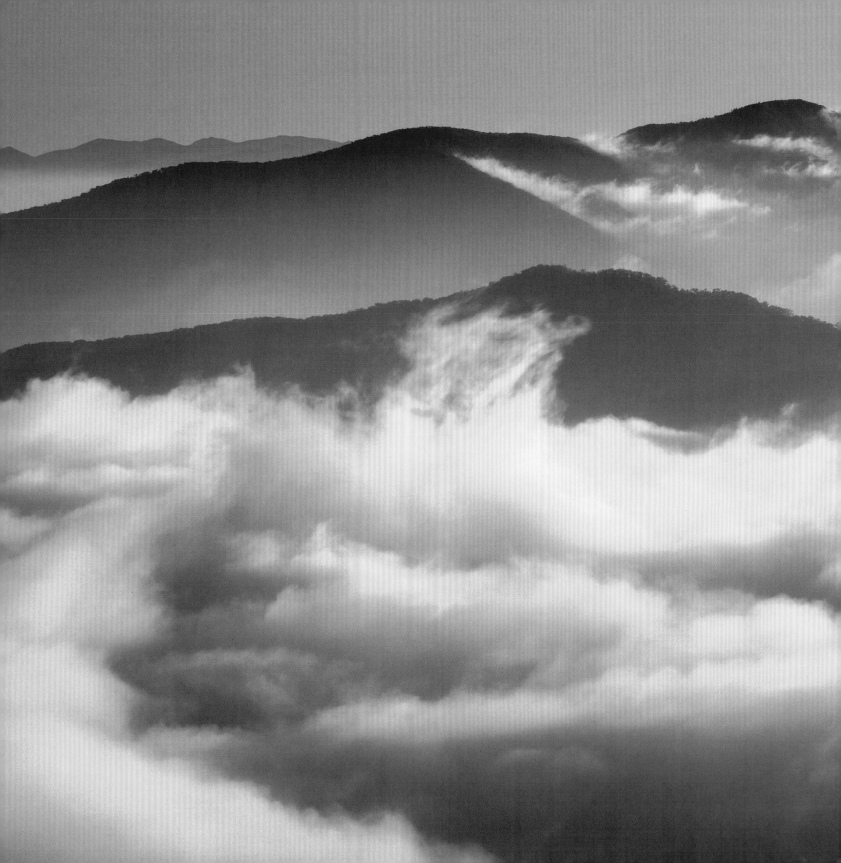

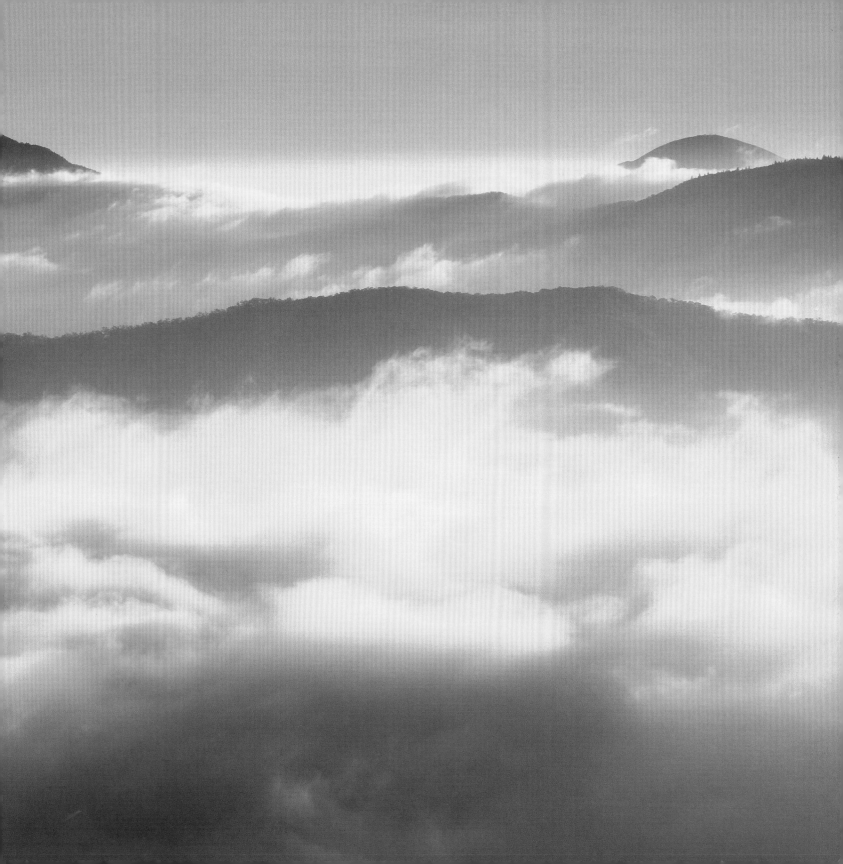

BLUE RIDGE PARKWAY
Wonder and Light

PHOTOGRAPHY BY

JERRY D. GREER IAN J. PLANT

Mountain Trail
Press

1818 Presswood Road • Johnson City, Tennessee 37604
www.mountaintrailpress.com

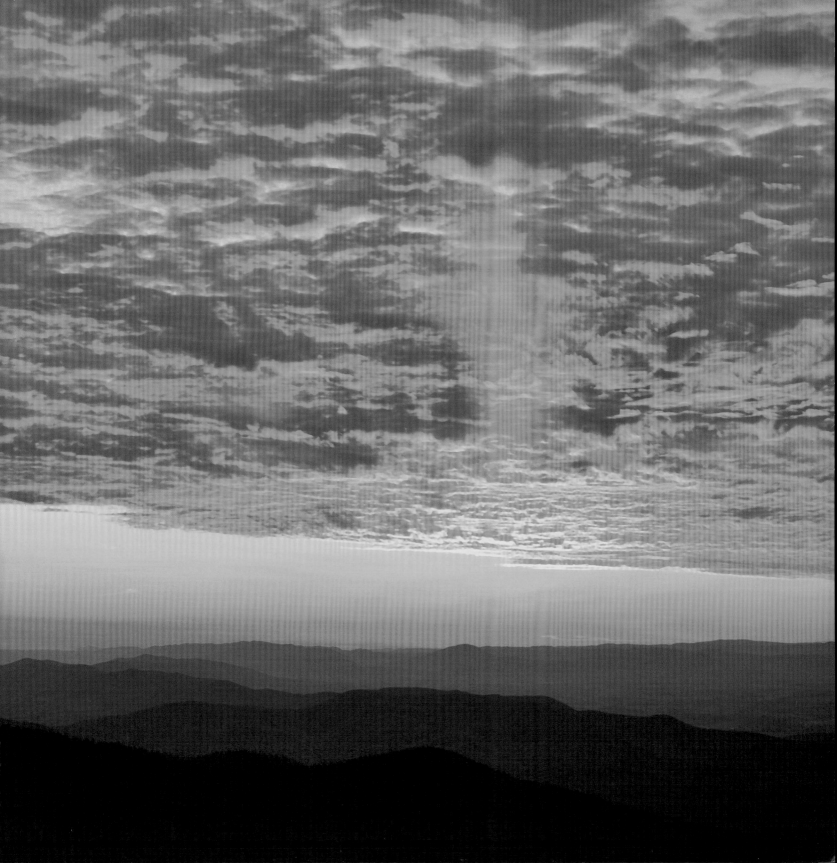

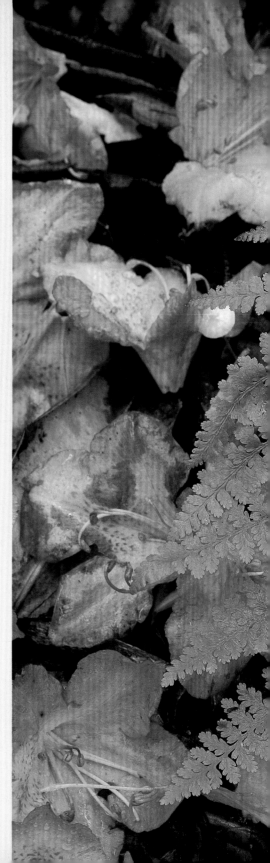

BLUE RIDGE PARKWAY
Wonder and Light

JERRY D. GREER IAN J. PLANT

Book design: Ian J. Plant and Jerry D. Greer
Editor: Todd Caudle
Entire Contents Copyright © 2005 Mountain Trail Press LLC
Photographs © 2005 Jerry D. Greer and Ian J. Plant
All Rights Reserved
No part of this book may be reproduced in any form without written permission from the publisher.
Published by Mountain Trail Press LLC
1818 Presswood Road
Johnson City, TN 37604
ISBN: 0-9770808-1-1
Printed in Korea
First Printing, Summer 2005

Front cover: Sunset in the Nantahala National Forest, as viewed from the Parkway in North Carolina (near milepost 430). Photo by Jerry D. Greer
Title page (frontpiece): Autumn maple and post fence, along the Parkway in North Carolina. Photo by Jerry D. Greer
Title page (background): Rhododendron blooms. Photo by Ian J. Plant
Full page spread: Cold Mountain and Mount Pisgah define the skyline, North Carolina (near milepost 426). Photo by Jerry D. Greer
Previous page: Sunset over Thunder Ridge, Virginia (milepost 75). Photo by Ian J. Plant
Right: Ferns and fallen rhododendron blossoms. Photo by Jerry D. Greer
Above: Spring storm over Table Rock (milepost 329). Photo by Jerry D. Greer

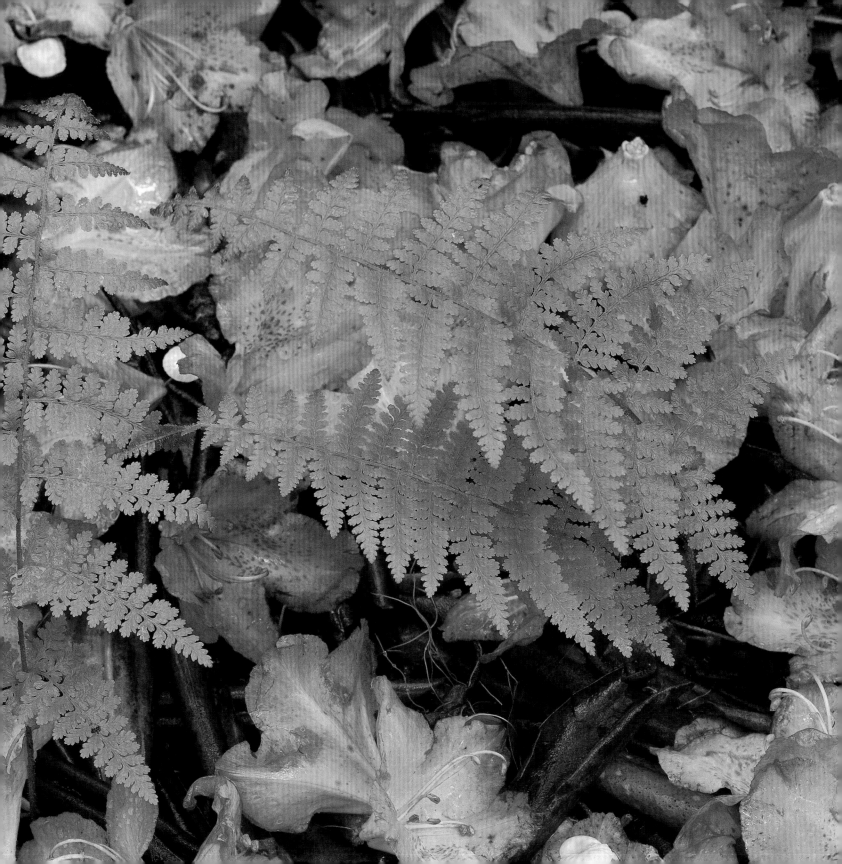

As I drive the winding road that is the 469-mile-long Blue Ridge Parkway, I often listen to one of my favorite bluegrass or old-time CD's. On this day I'm listening to a wonderful new release by Tim and Debbie Yates, local old-time musicians from Damascus, Virginia. Their title song is "The Mountains are Where You Long to Be". What a great title! The entire CD is a very fitting musical compilation for traveling along the Parkway. As a native of these mountains, I have a special love for these old hills and everything contained within. It's the music, the people, the stories, but most of all, the mountains, from the lowlands of the James River to the lofty heights of the Black Balsams. In a word, home.

Old-time music is a part of everyone who grew up on the ridges and in the hollows of the Blue Ridge Mountains. As I listen to a banjo played claw hammer-style, or an Appalachian long-bow fiddle played by an old master, I'm reminded that the lives of my ancestors are revealed and celebrated in the melody and lyrics of every song. When music and the mountains come together, I am transported back to a wondrous, yet very hard time when my ancestors were growing up in these mountains. I often visualize my grandfather as a young boy, running through the hills or working with a team of plow horses. Having come of age under much easier circumstances, I can only daydream about what it was like back then, aided by his stories still vivid in my mind decades after first hearing them.

The families that came to live in these mountains were self-sustaining. A few still are to this day. They farmed the land to feed their families, and to make a few bucks to buy the few necessities that they couldn't make for themselves. Even today, when you exit the Parkway at Grandfather Mountain, you can stop and buy mountain-made molasses and pure clover honey from the locals. Back in the day, some were also crafters, many of whom passed their skills from generation to generation. You'll see evidence of this along the entirety of the Blue Ridge Parkway, and even have the ability to purchase hand-crafted items at numerous locations.

Foreword

by Jerry D. Greer

The Blue Ridge Parkway offers today's traveler a glimpse into a simpler time. It also presents today's traveler wondrous views of receding ridgelines and lofty mountain peaks. To truly enjoy the many offerings of the Parkway, though, today's traveler must take the time to absorb the history, the music and the wonderful mountain views through observations made beyond the windows of an automobile. Stop and meet my friends and fellow Appalachian folk along the way. If you take the time to visit, they may disclose one of their secret locations off the beaten path that could turn a good trip into a great one that you'll remember for a lifetime!

I hope that each traveler along this wonderful drive through history and mountain beauty will take with them a little of our sense of pride. We all must work diligently to protect the views of the Blue Ridge Parkway and natural habitats along the Parkway corridor. The preservation of these mountains is made possible, in large part, by the stewardship of local conservation groups, including Friends of the Blue Ridge Parkway, Southern Appalachian Highlands Conservancy, Southern Appalachian Biodiversity Project, and Appalachian Voices. I would like to personally thank all of them and their armies of volunteers for helping to protect our home.

Above: Dusk over the North Carolina Highlands (near milepost 435). Photo by Jerry D. Greer

Right: Autumn surrounds North Carolina's Crabtree Falls (near milepost 339). Photo by Jerry D. Greer

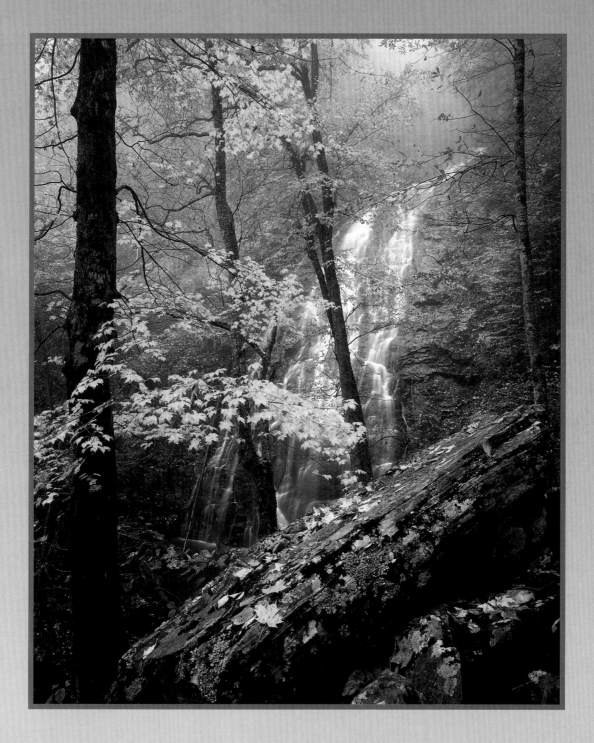

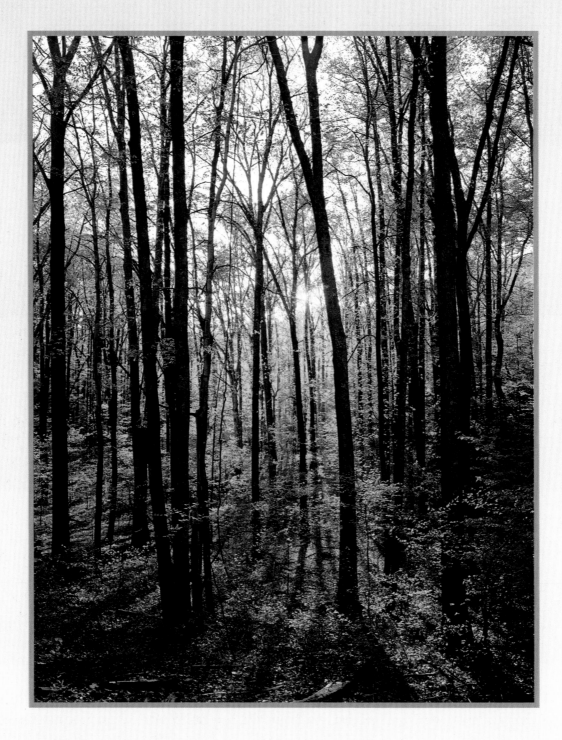

The Blue Ridge Parkway is an engineering and architectural wonder. The Parkway twists and turns through the high peaks of several southern Appalachian mountain chains, chief of which are the Blue Ridge Mountains. One finds it difficult to even imagine the enormous effort and skill required to construct this 469-mile sliver of asphalt through some of the most rugged mountain territory in the Eastern United States. It seems almost impossible. Yet after more than fifty years of toil, the impossible was brought to fruition in 1987 when the section containing Linn Cove Viaduct, a graceful curving bridge set high above the clouds, was finally completed.

The man-made wonder of the Parkway, however, pales in comparison to the natural architecture of the Blue Ridge Mountains which it sits astride. Formed several hundred million years ago when ancient continents collided, the Blue Ridge Mountains were once much higher than they are today, probably on a scale resembling the present-day Rocky Mountains. But wind and rain are stronger than rocks, and for the last 100 million years the forces of nature have carved away the mountains, leaving only their rocky cores. Yet even their cores are still mighty and awe-inspiring, remnant thought they be of a far greater past.

One can get lost gazing into the endless ridges of the Blue Ridge Mountains. Two locations in particular are great for ridge viewing. One is in the highlands of North Carolina, at the Cowee Mountain Overlook at Parkway milepost 433. The other is in central Virginia, overlooking Thunder Ridge (best viewed at the Arnold Valley Overlook, at milepost 75). Both offer superlative views of infinite Appalachian ridges. As classic as these views are, there are literally hundreds of spots on the Parkway that offer their own unique and grand perspectives of the beautiful Blue Ridge landscape.

In places the gentle rolling ridges are interrupted by jagged peaks, those that have resisted more vigorously the forces of nature. Humpback Rocks (milepost 5), Peaks of Otter (milepost 85), Grandfather Mountain (milepost 306), Looking Glass Rock (milepost 417), and Mount Mitchell, the highest point east of the Mississippi River at 6,684 feet (milepost 355), are all striking examples.

The Parkway also offers visitors the opportunity to witness the very forces that have through time ground the mountains down. Mighty rivers carve great swathes through the Blue Ridge, including the James in Virginia (milepost 63) and the French Broad in North Carolina (milepost 393). Countless smaller waterways can be found as well, steadily eroding the hard granite. In some places the erosion is quite dramatic; Linville River cuts a deep gorge into the surrounding mountains, and plunges over dramatic 45-foot high Linville Falls (milepost 316). Other large waterfalls on the Parkway include Apple Orchard Falls (milepost 78); Falling Water Cascades (milepost 83); Cascades (milepost 271); Crabtree Falls – two, in fact, one in Virginia near milepost 27 and one in North Carolina at milepost 339; and the waterfalls of Graveyard Fields (milepost 418). Many other smaller cascades and streams abound.

Introduction

by Ian J. Plant

So much geographic diversity makes the Parkway both an inspiring and daunting place to photograph. Inspiring because there are so many stunning scenes to shoot; and daunting for the very same reason. To truly do the Parkway justice, one needs a lifetime, perhaps several. So it is with some trepidation that we offer less than a lifetime's worth of work, knowing that Nature herself will always outdo us. Nonetheless, we humbly offer this book as a proxy, a compilation of several years worth of images of this beautiful land, for the times that you cannot return yourself and see the Parkway in all its glory.

Above: Sun streaks over Graveyard Fields, North Carolina (near milepost 418). Photo by Ian J. Plant

Left: Last light illuminates a spring forest along the Virginia portion of the Parkway. Photo by Ian J. Plant

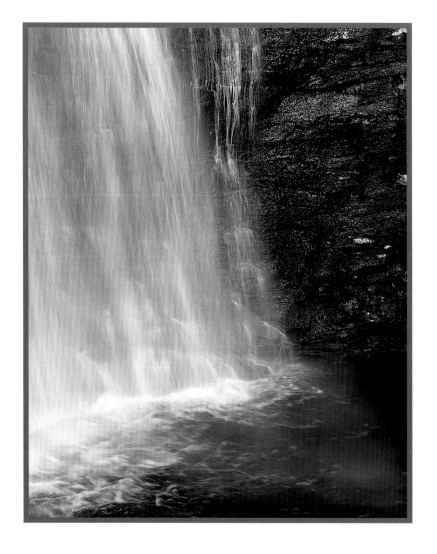

Above: Rainbow over Looking Glass Falls, North Carolina (near milepost 411).
Photo by Ian J. Plant

Right: Winter comes to the Parkway. Photo by Jerry D. Greer

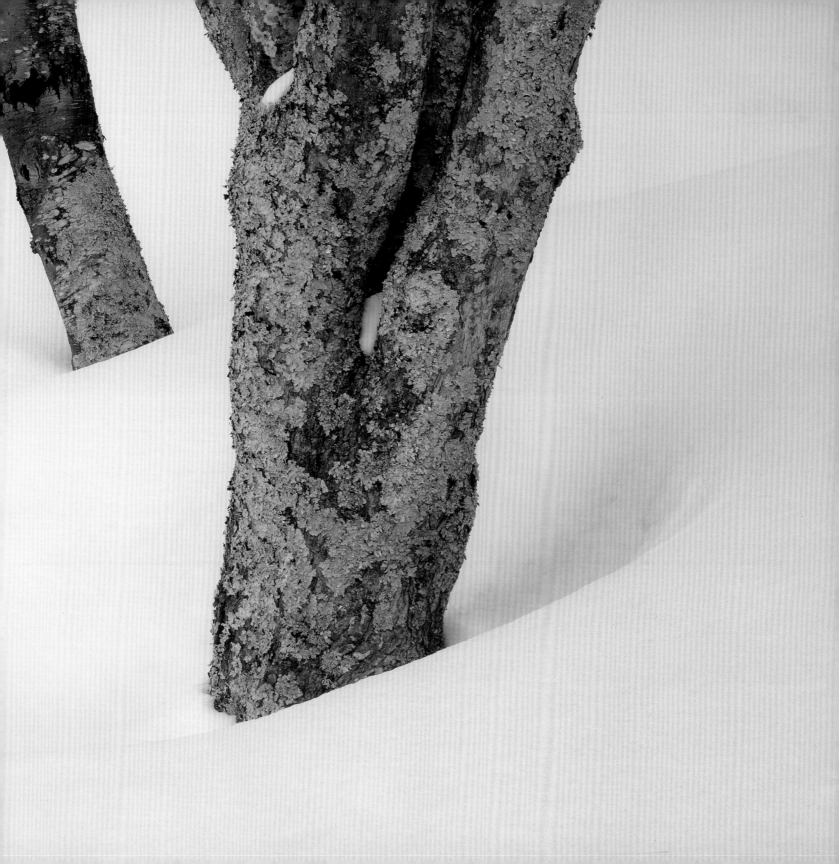

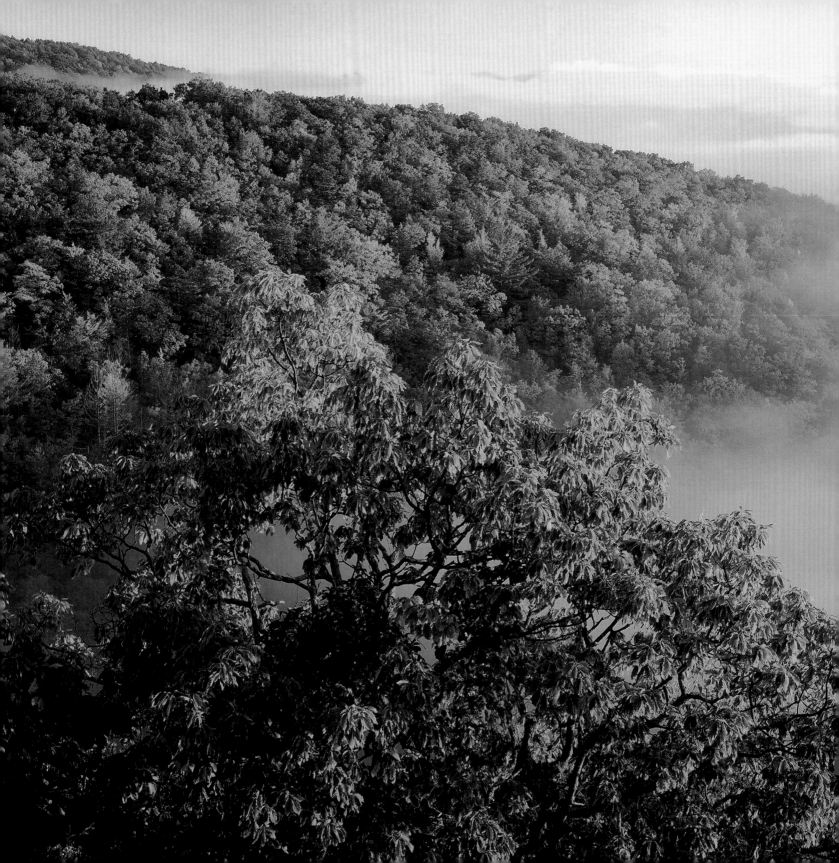

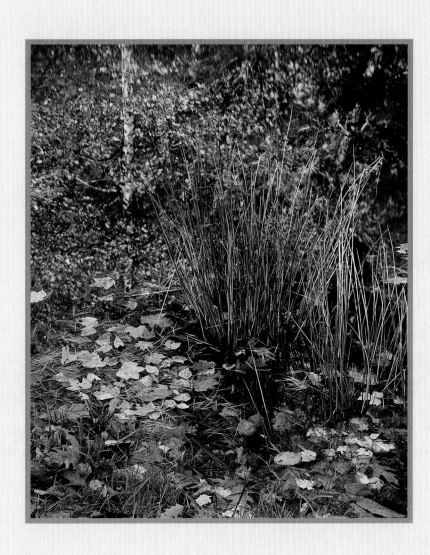

Above: Reeds and autumn reflections, Rakes Mill Pond, Virginia (milepost 162).
Photo by Ian J. Plant

Left: Early autumn sunset, North Carolina (near milepost 326). Photo by Jerry D. Greer

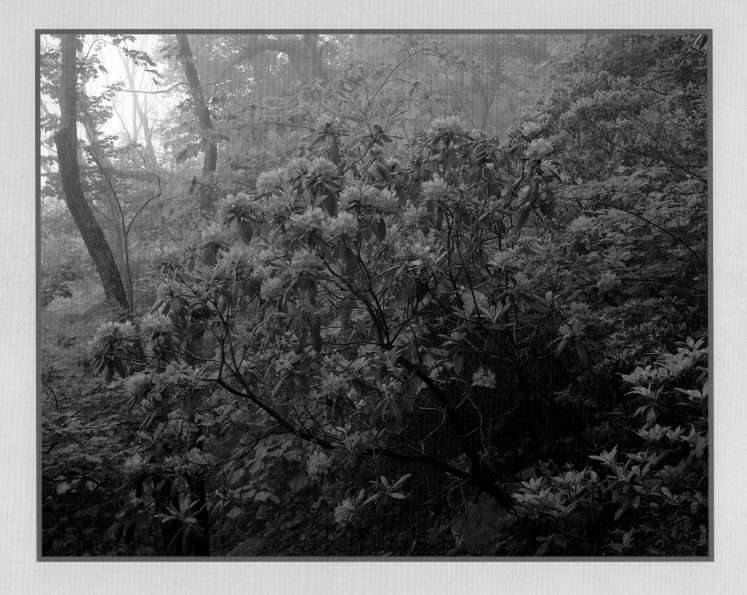

Above: Blooming rhododendron in fog, along the Apple Orchard Falls Trail, Virginia (near milepost 76). Photo by Ian J. Plant

Right: Second Falls, Yellowstone Prong of the East Fork of the Pigeon River, North Carolina (near milepost 418). Photo by Jerry D. Greer

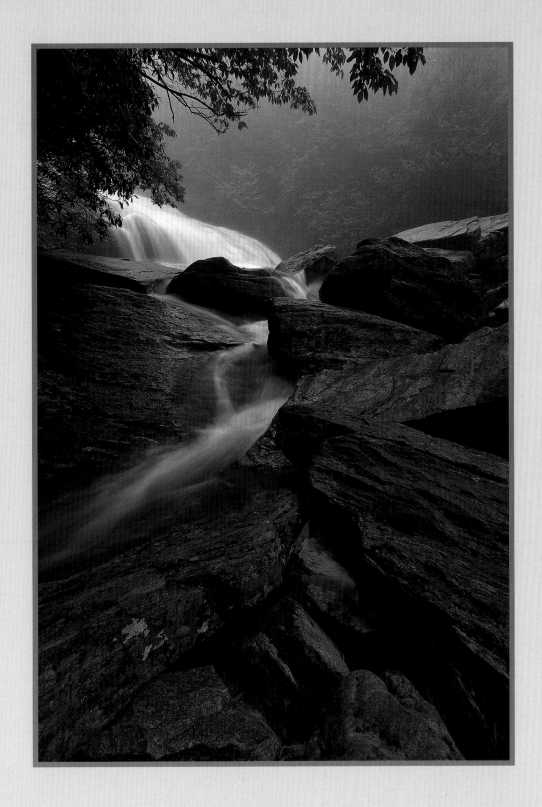

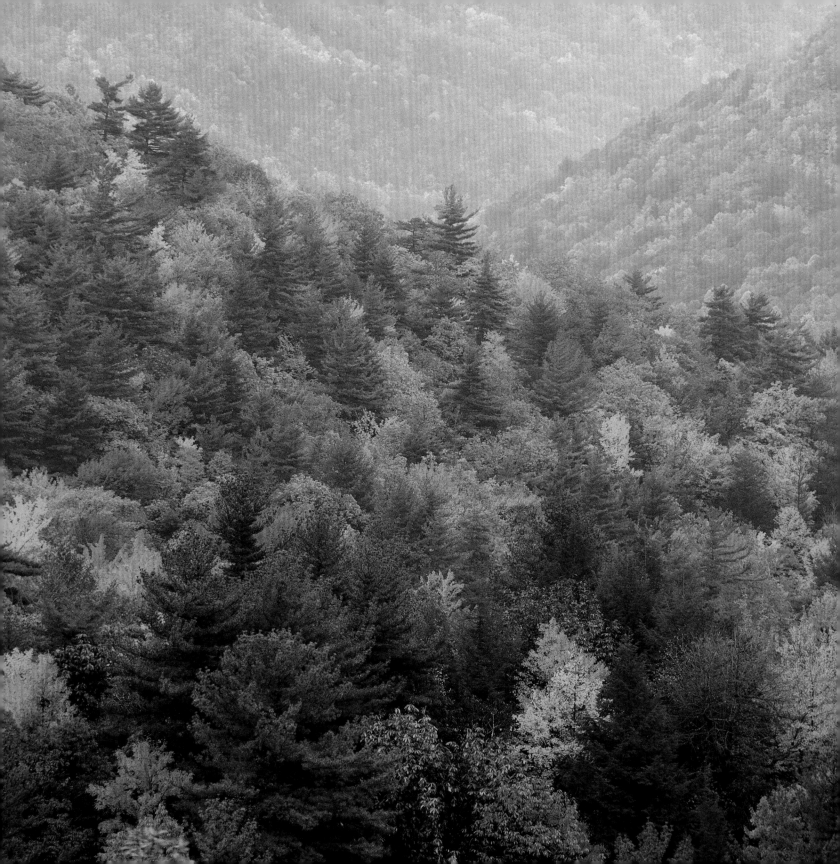

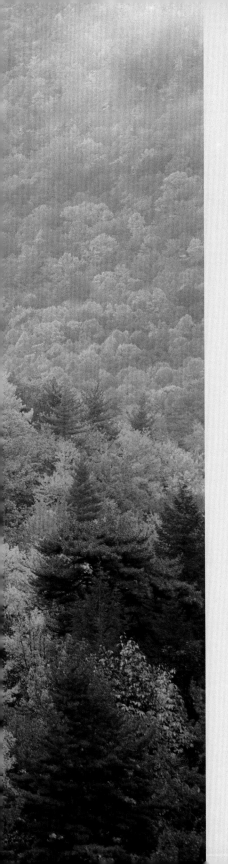

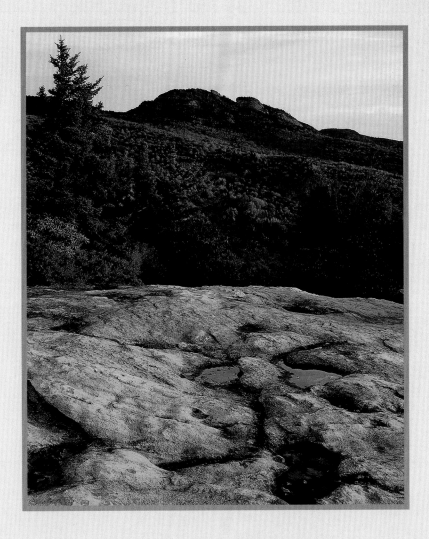

Above: Grandfather Mountain in autumn, North Carolina (near milepost 306).
Photo by Jerry D. Greer

Left: Autumn trees along the Parkway in North Carolina (near milepost 312).
Photo by Jerry D. Greer

Next page: Spring comes to Graveyard Fields, North Carolina (milepost 418).
Photo by Jerry D. Greer

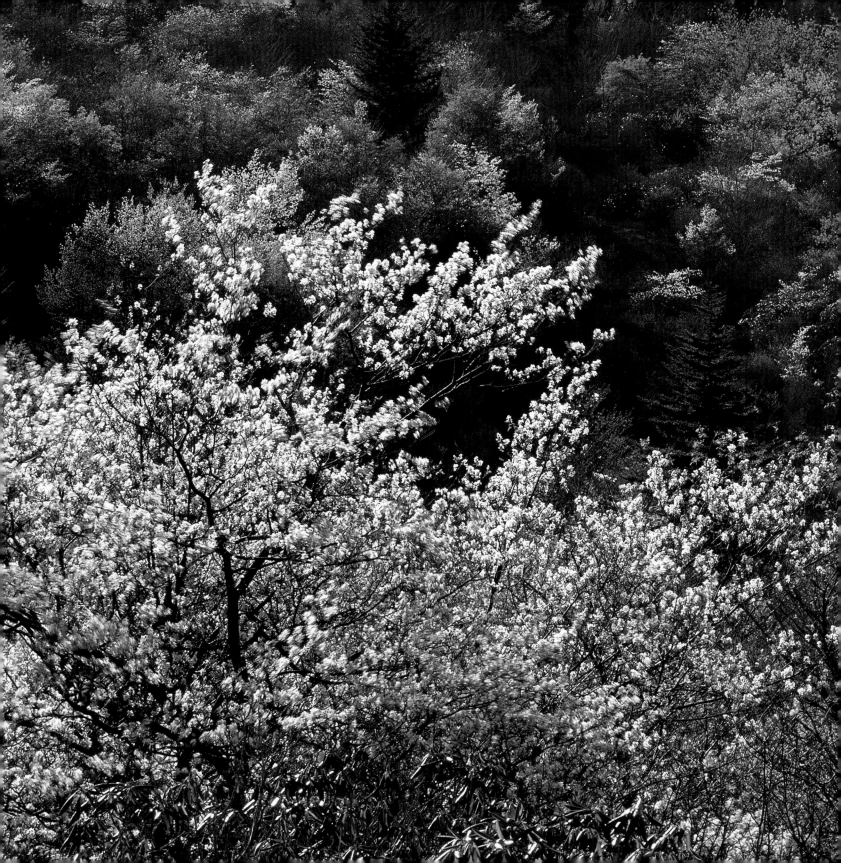

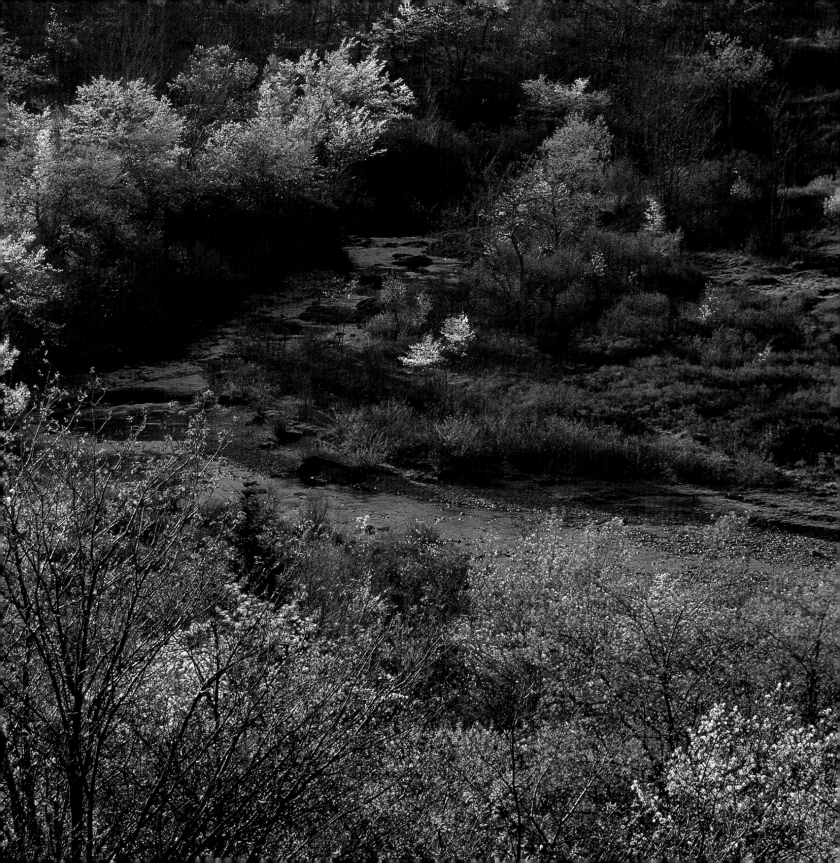

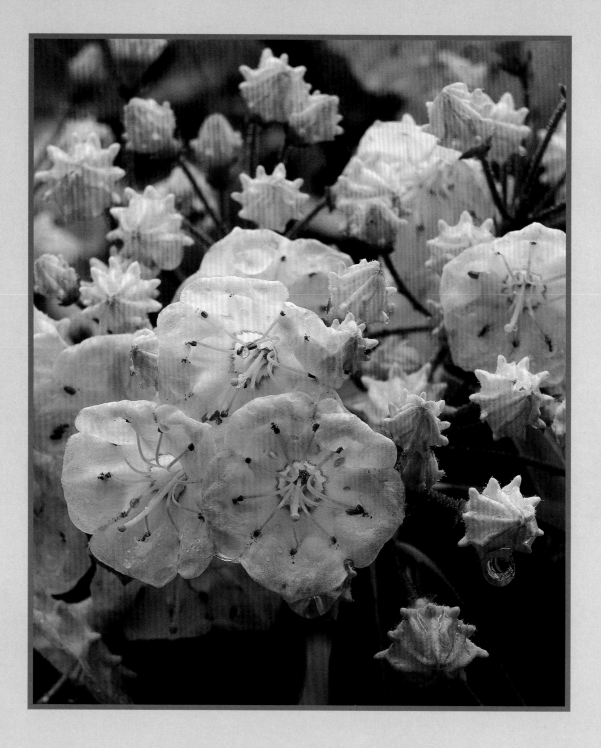

Blooming mountain laurel. Photo by Jerry D. Greer

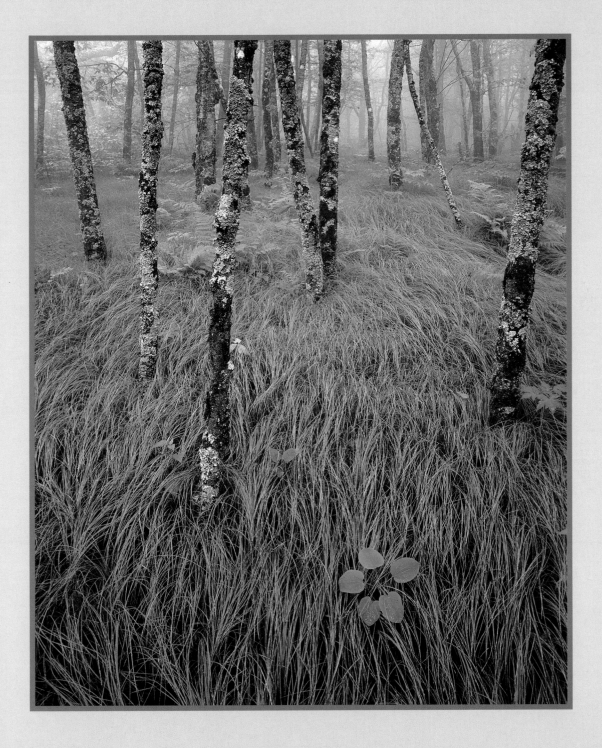

A river of grass flows through Craggy Gardens, North Carolina (near milepost 367). Photo by Ian J. Plant

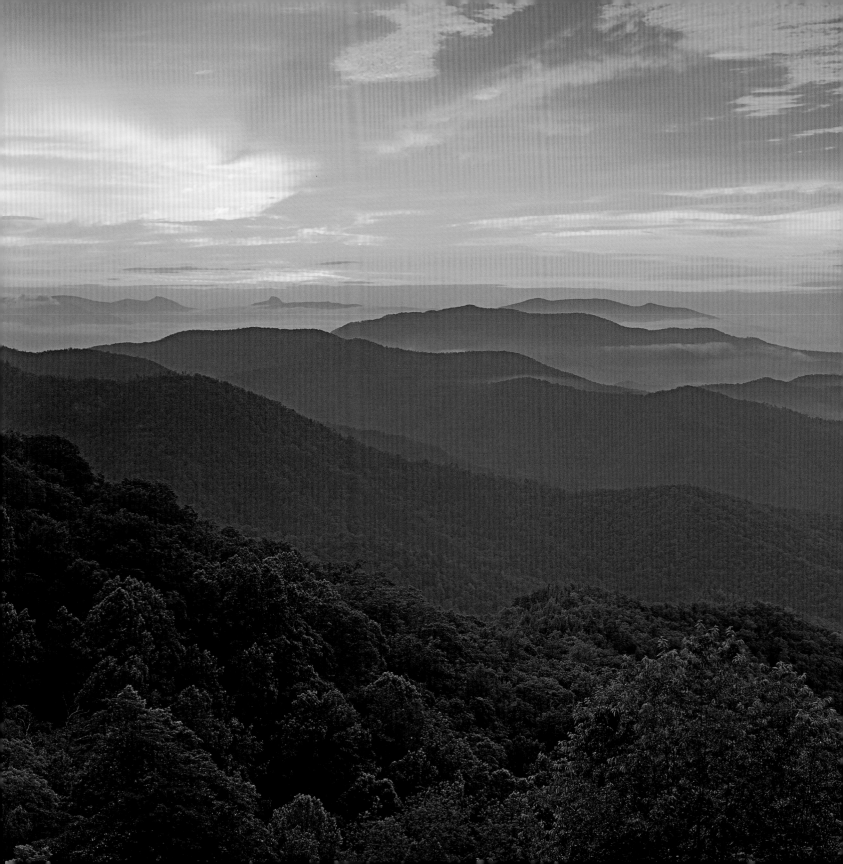

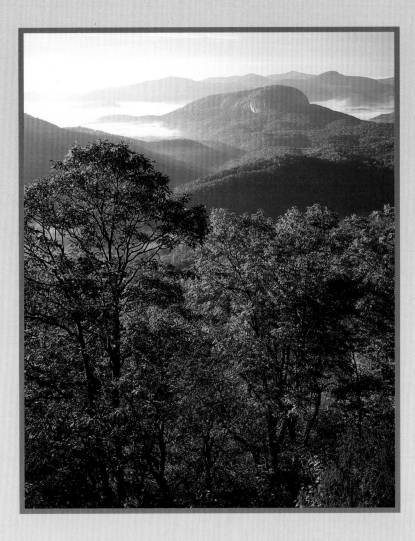

Above: Fall morning vista of Looking Glass Rock, North Carolina (milepost 417).
Photo by Jerry D. Greer

Left: Sunrise over the North Carolina Highlands. Photo by Ian J. Plant

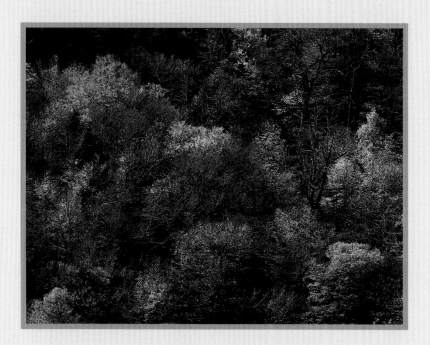

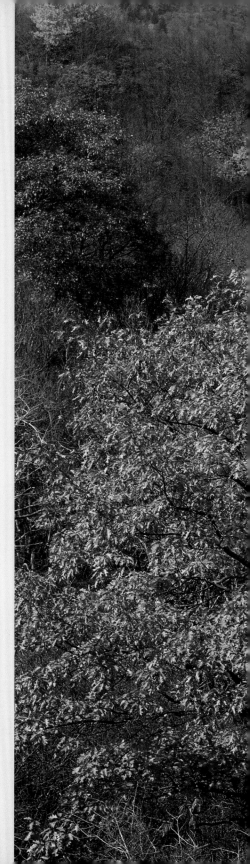

Above: A lone maple turns crimson in autumn. Photo by Jerry D. Greer

Right: Fall color at Graveyard Fields, North Carolina (milepost 418). Photo by Ian J. Plant

Next page: Dusk settles over the Cowee Mountains in North Carolina (milepost 430).
Photo by Ian J. Plant

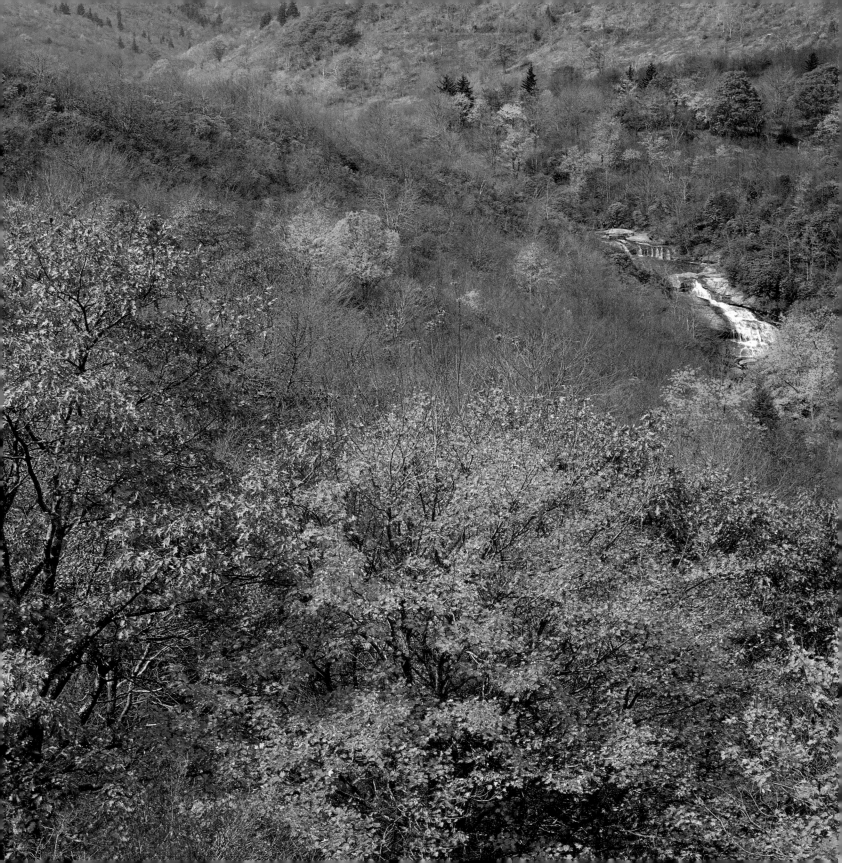

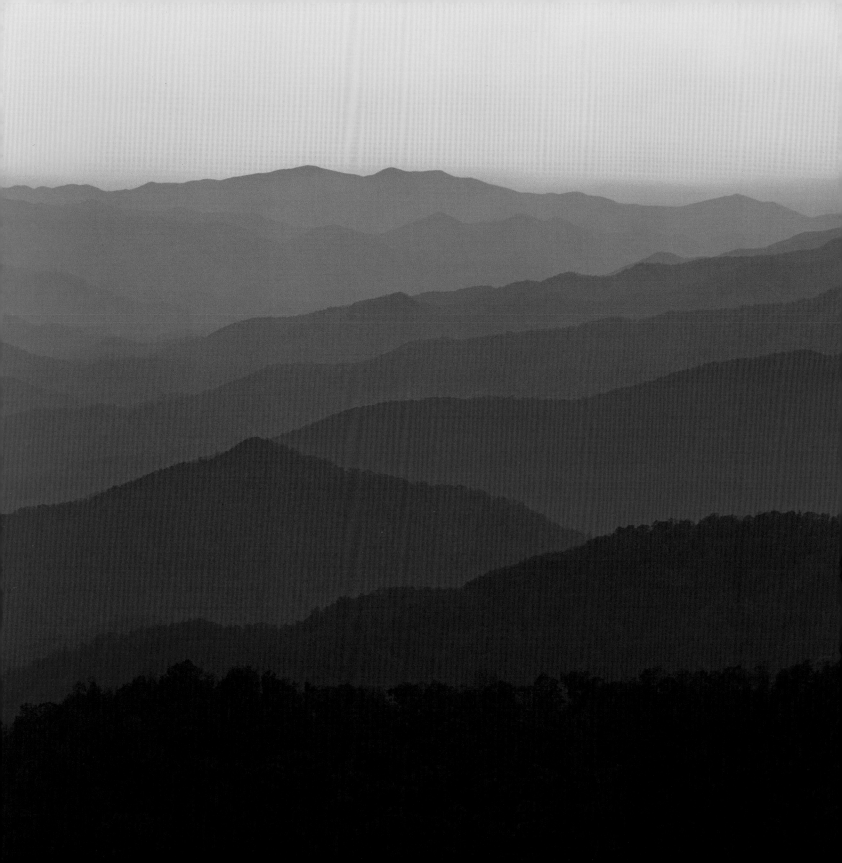

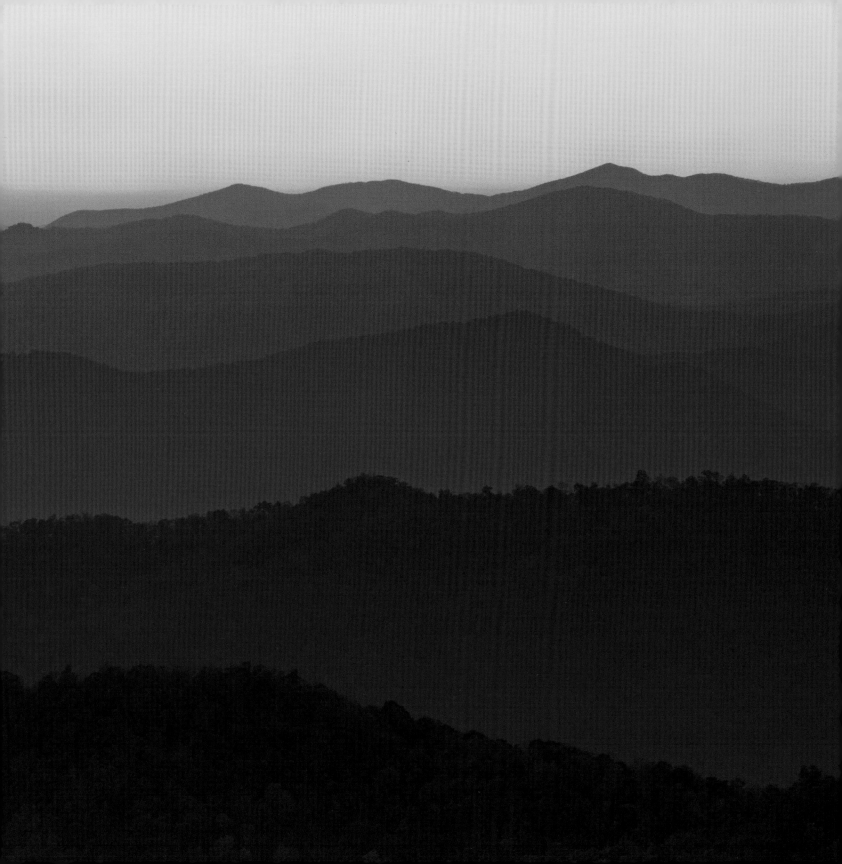

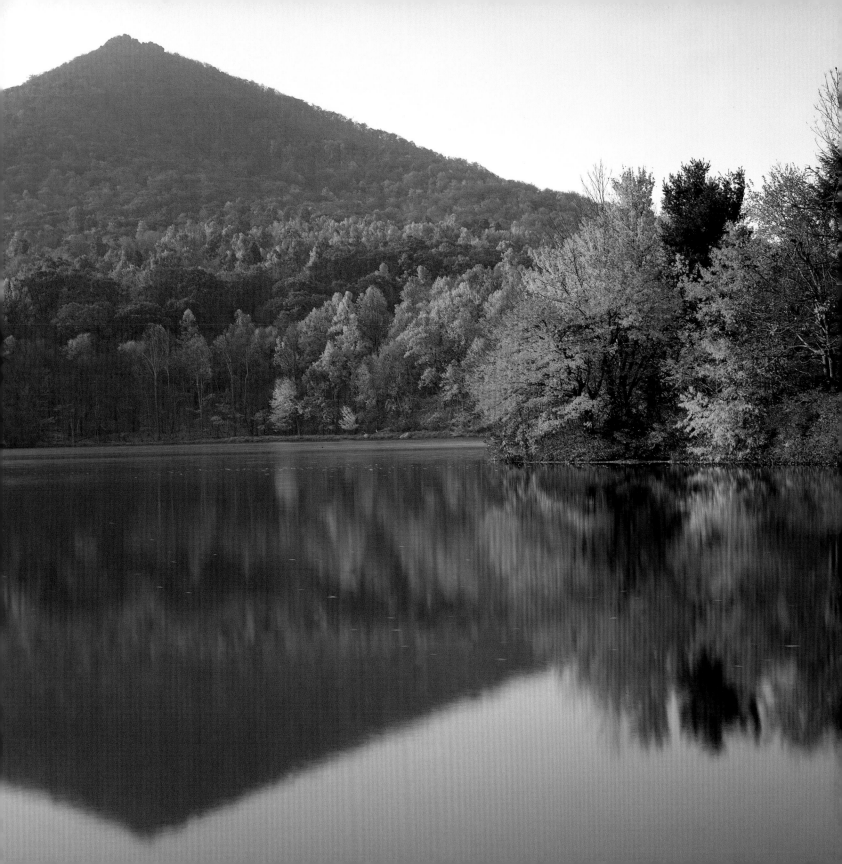

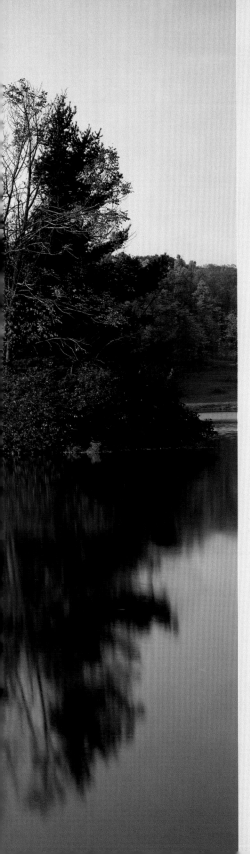

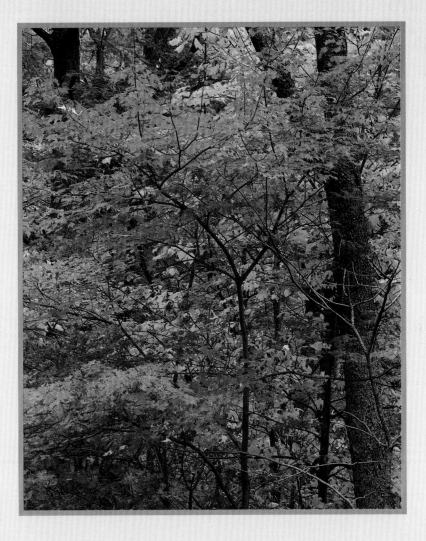

Above: Fall color along the Parkway in Virginia. Photo by Jerry D. Greer

Left: Fall color at Abbott Lake, Peaks of Otter, Virginia (milepost 85). Photo by Ian J. Plant

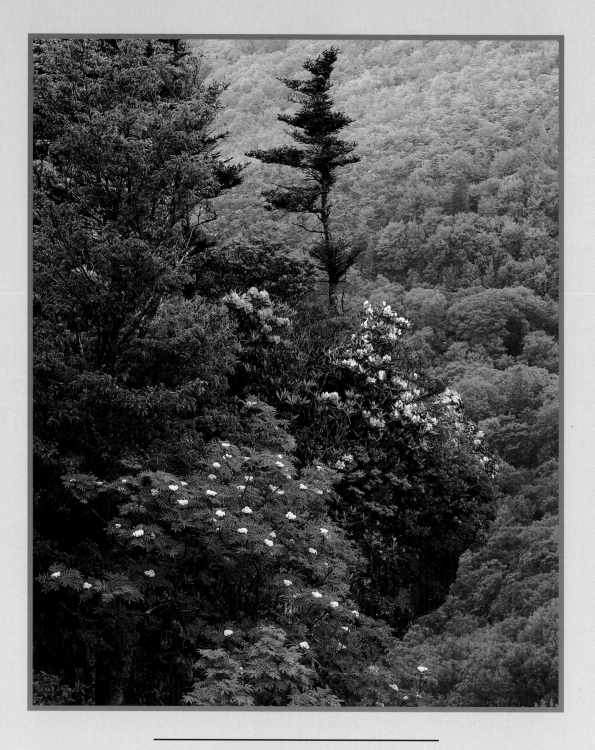

Lone pine and blooming rhododendron, Rough Ridge, North Carolina (near milepost 302).
Photo by Jerry D. Greer

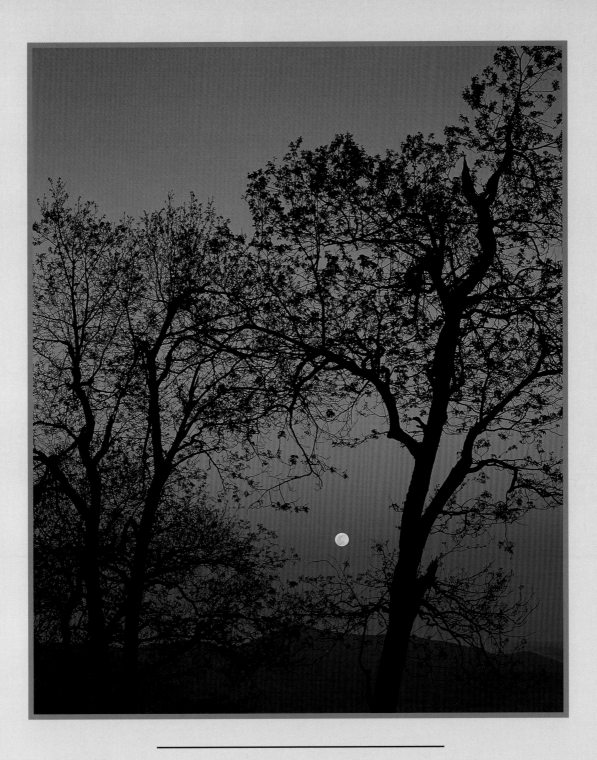

Moonrise through earthshadow, Virginia. Photo by Ian J. Plant

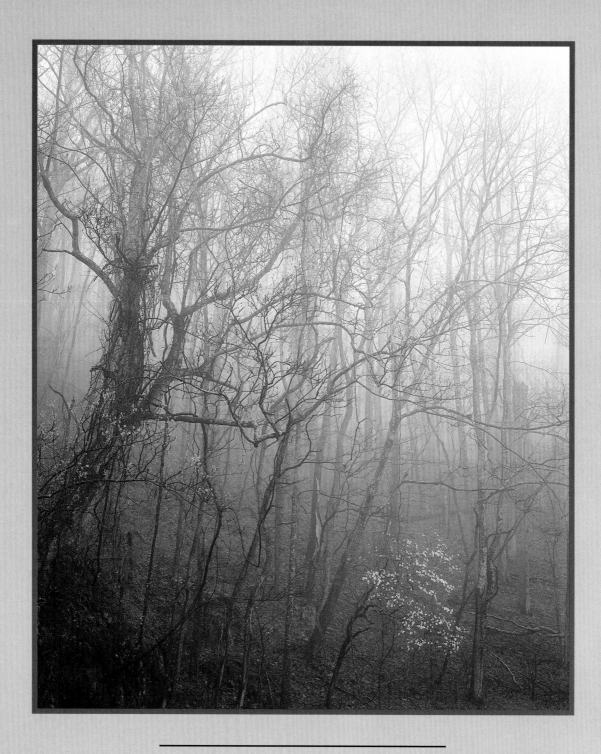

Lone dogwood tree, North Carolina. Photo by Ian J. Plant

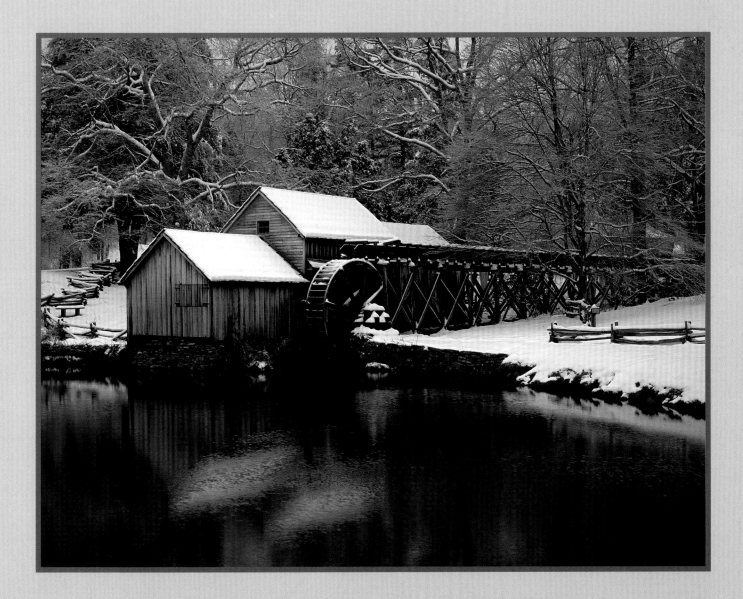

Mabry Mill in winter, Virginia (milepost 176). Photo by Jerry D. Greer

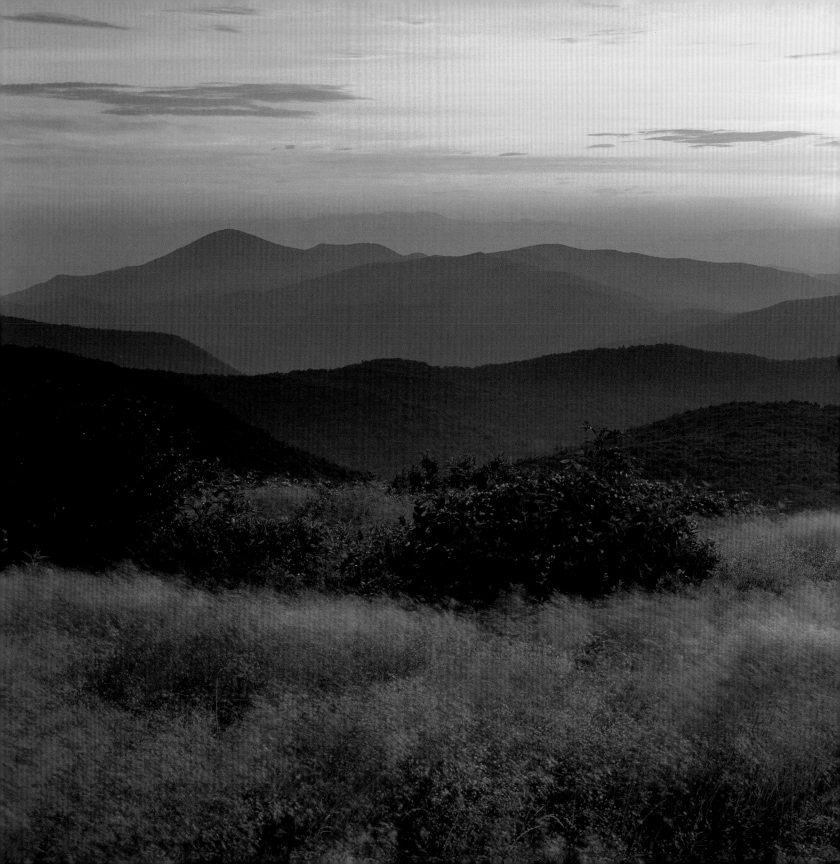

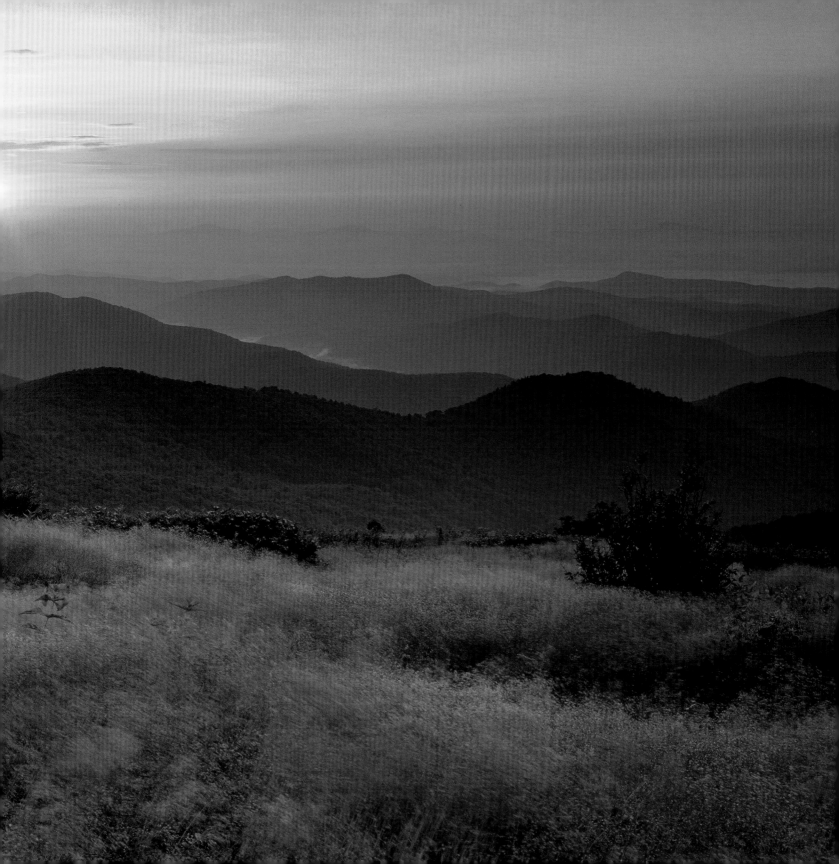

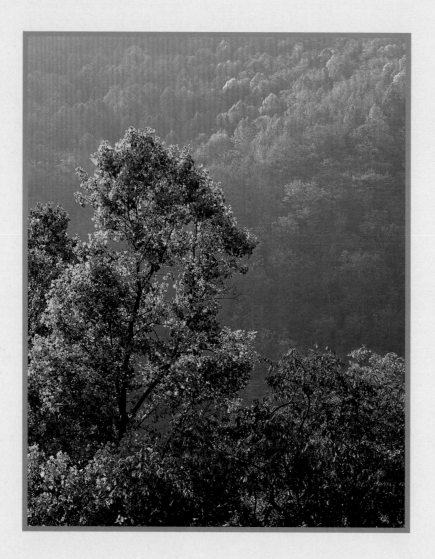

Previous page: Sunset over Tennent Mountain, North Carolina (near milepost 423).
Photo by Jerry D. Greer

Above: Fall color along the Parkway in Virginia. Photo by Ian J. Plant

Right: Along the Art Loeb Trail in North Carolina (near milepost 421). Photo by Jerry D. Greer

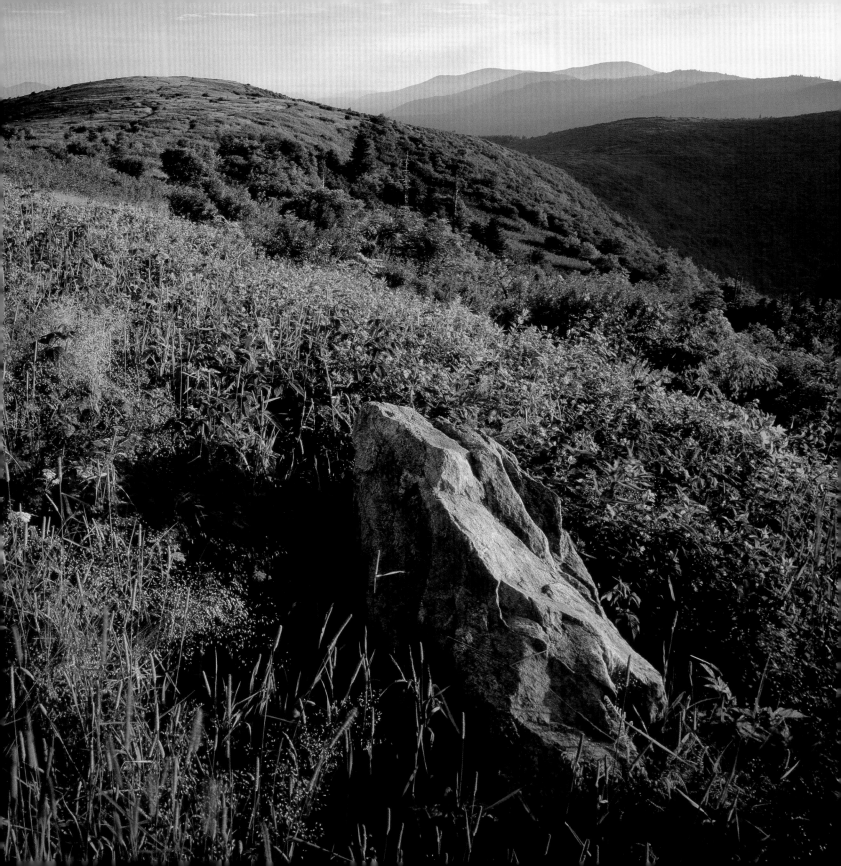

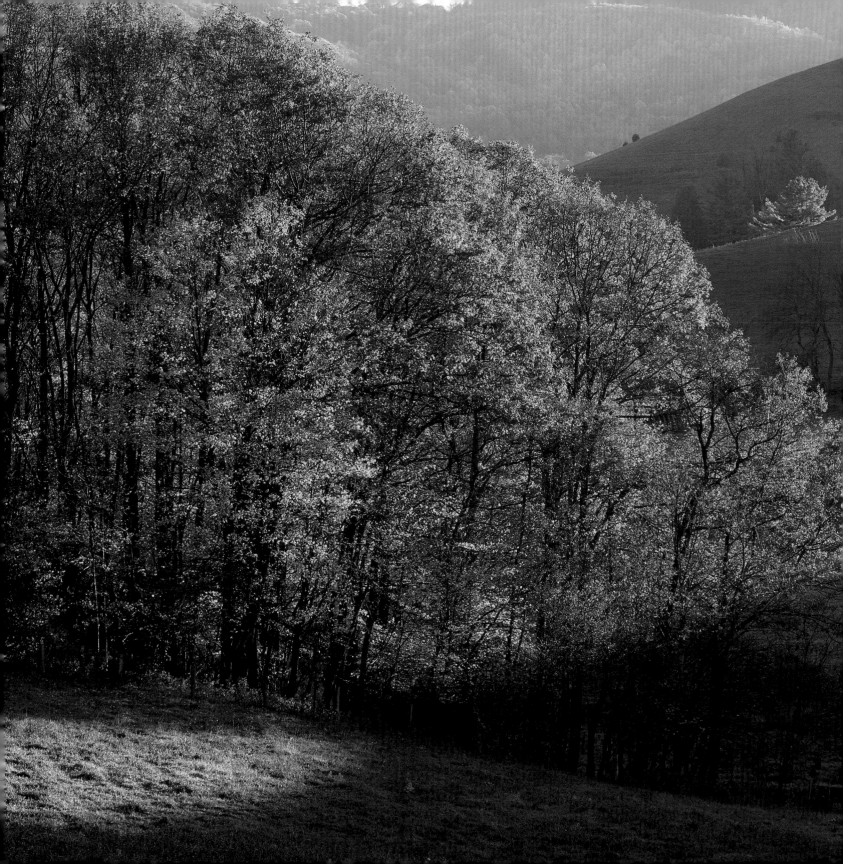

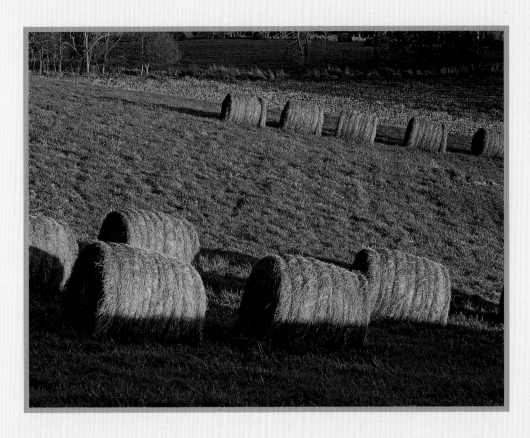

Above: Hayfields are common in the pastoral sections of the Virginia Parkway.
Photo by Ian J. Plant

Left: Fall color graces a farmer's field, Virginia. Photo by Ian J. Plant

Next page: Roan Highlands at sunset as viewed from the Parkway, North Carolina.
Photo by Jerry D. Greer

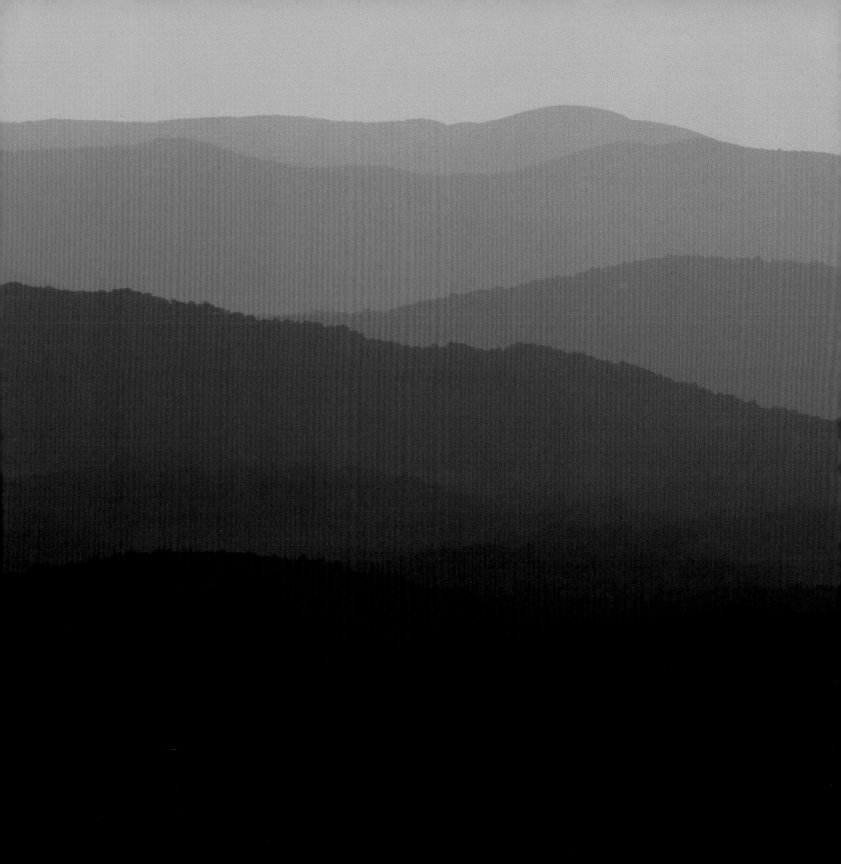

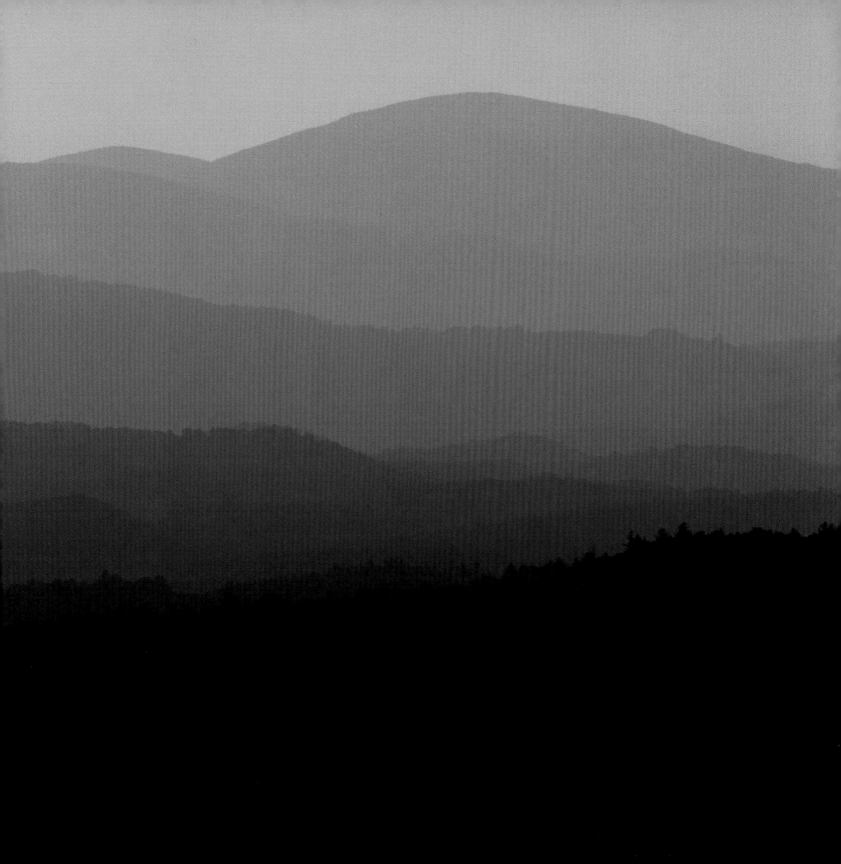

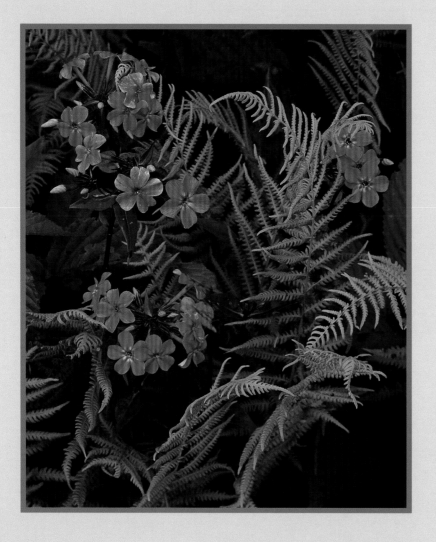

Above: Wild blue phlox and ferns along the Parkway in North Carolina.
Photo by Jerry D. Greer

Right: Linville Falls in North Carolina (near milepost 316). Photo by Ian J. Plant

Next page: Price Lake at sunset, North Carolina (milepost 296). Photo by Jerry D. Greer

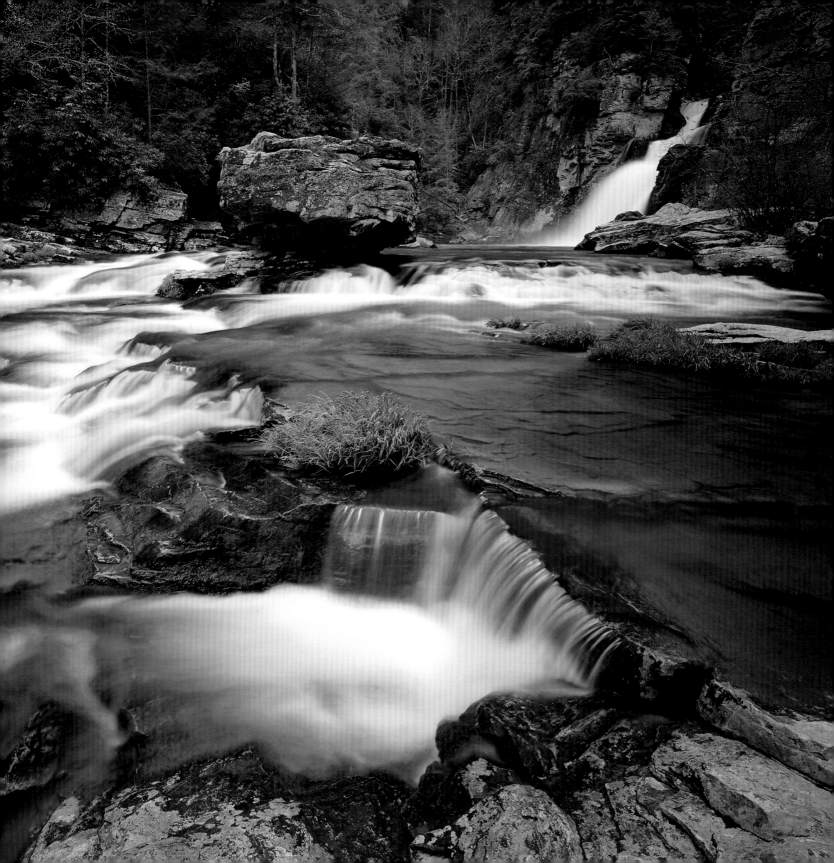

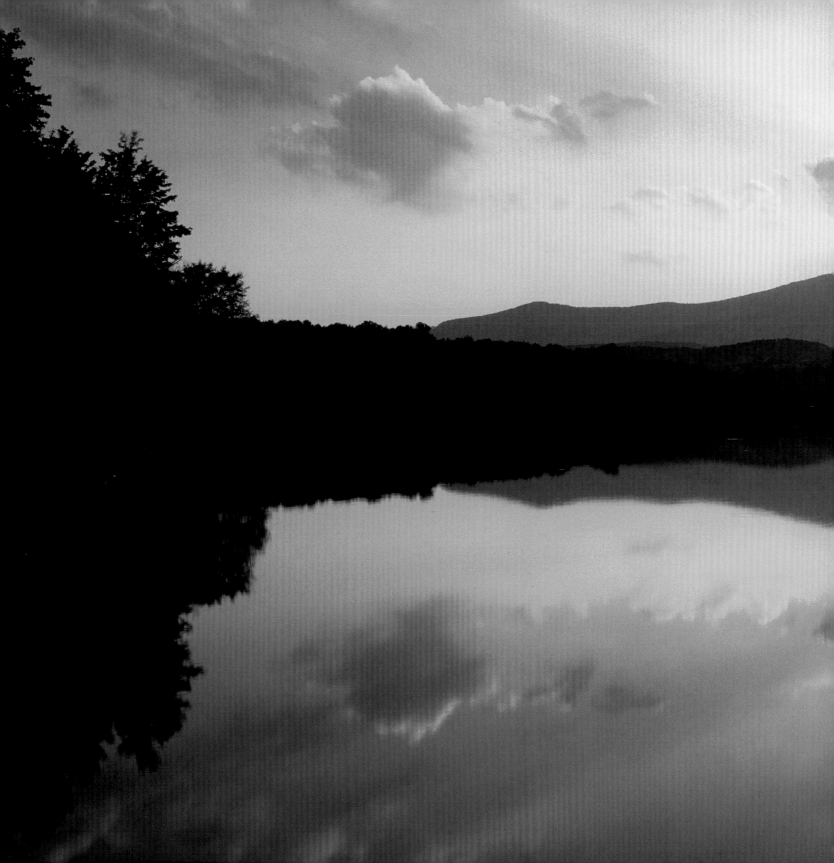

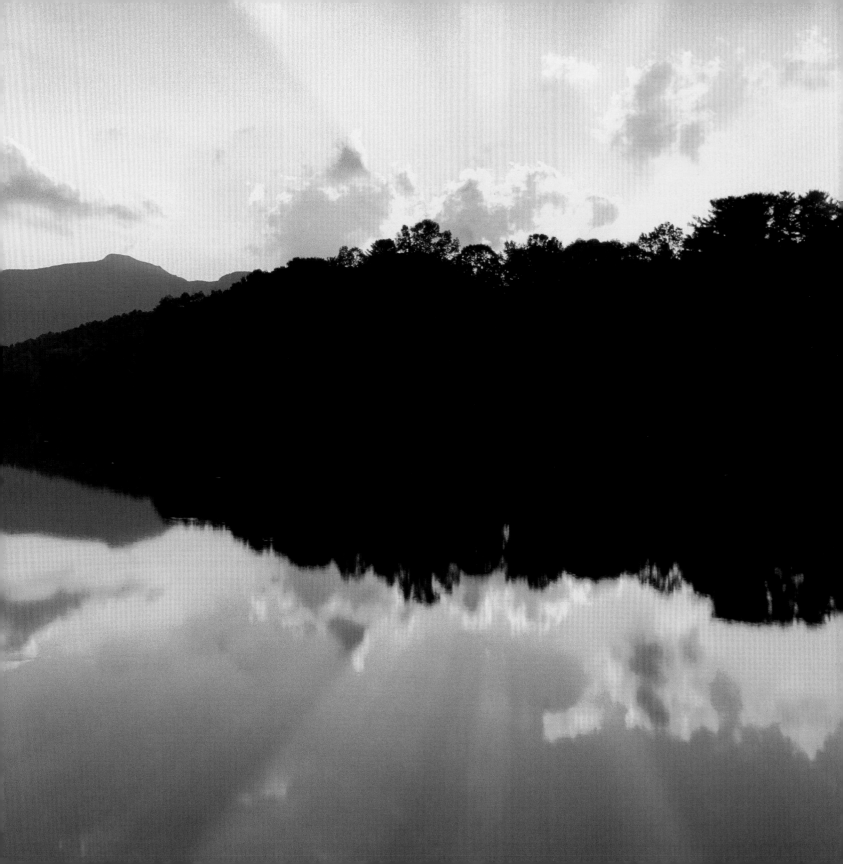

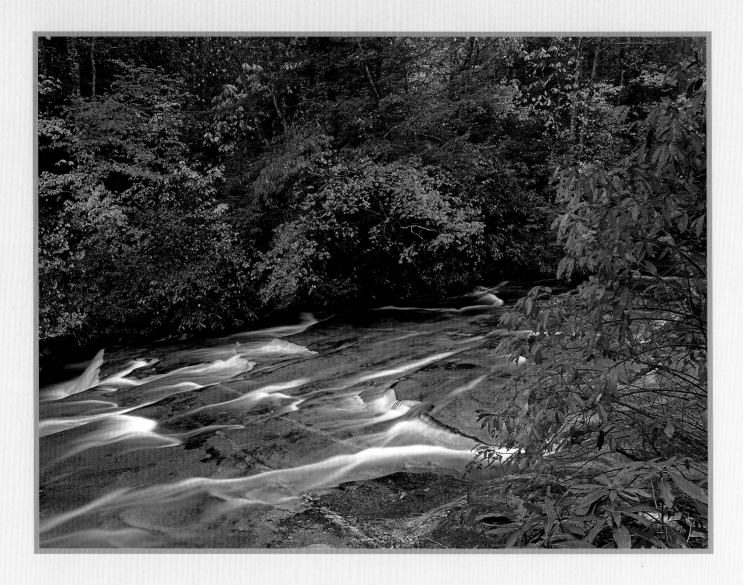

Above: Fall color along Looking Glass Creek, North Carolina (near milepost 411).
Photo by Jerry D. Greer

Right: Fall color mixes with pine cones and needles, Virginia. Photo by Ian J. Plant

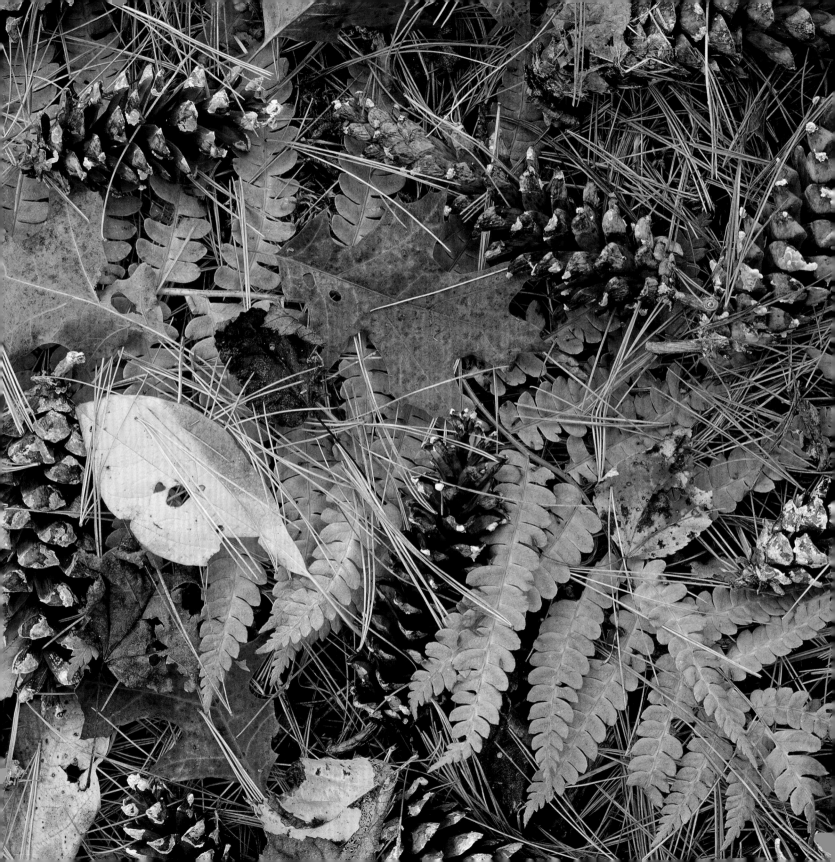

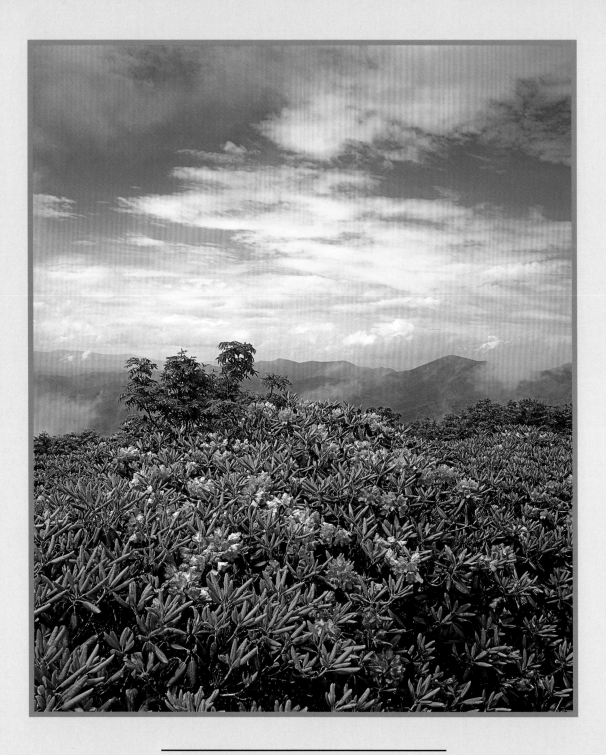

Craggy Gardens bloom in June, North Carolina (milepost 364). Photo by Ian J. Plant

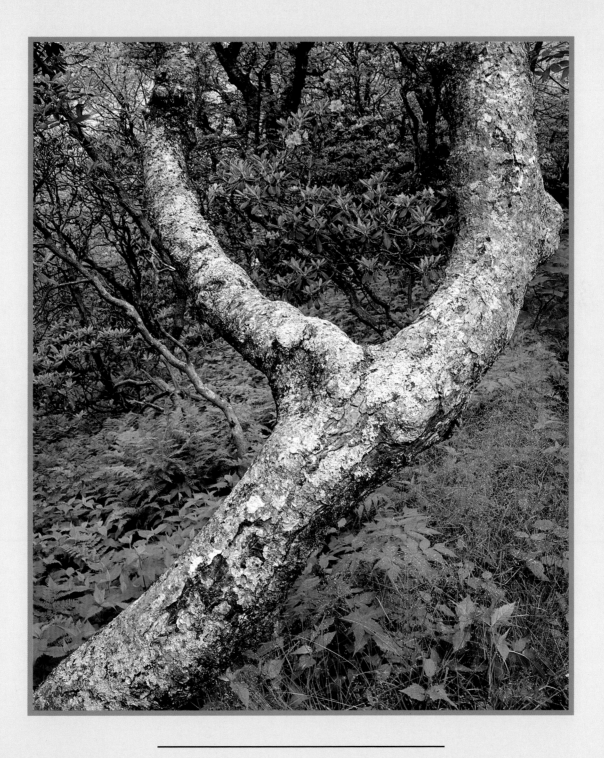

A forked tree frames rhododendron blossoms, Craggy Gardens, North Carolina (near milepost 367). Photo by Ian J. Plant

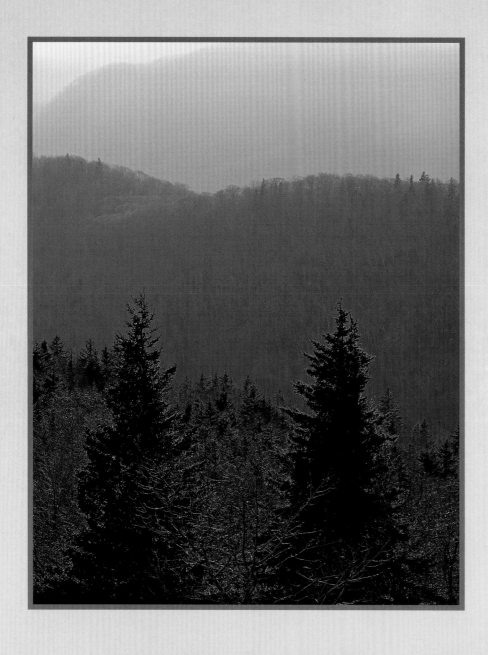

Above: Sunset back-lights pine trees along the Parkway in North Caolina. Photo by Ian J. Plant

Right: Winter view of Tablerock and Hawksbill Mountains, North Carolina (near milepost 304).
Photo by Jerry D. Greer

Next page: Sunrise over the Blue Ridge Mountains, North Carolina. Photo by Ian J. Plant

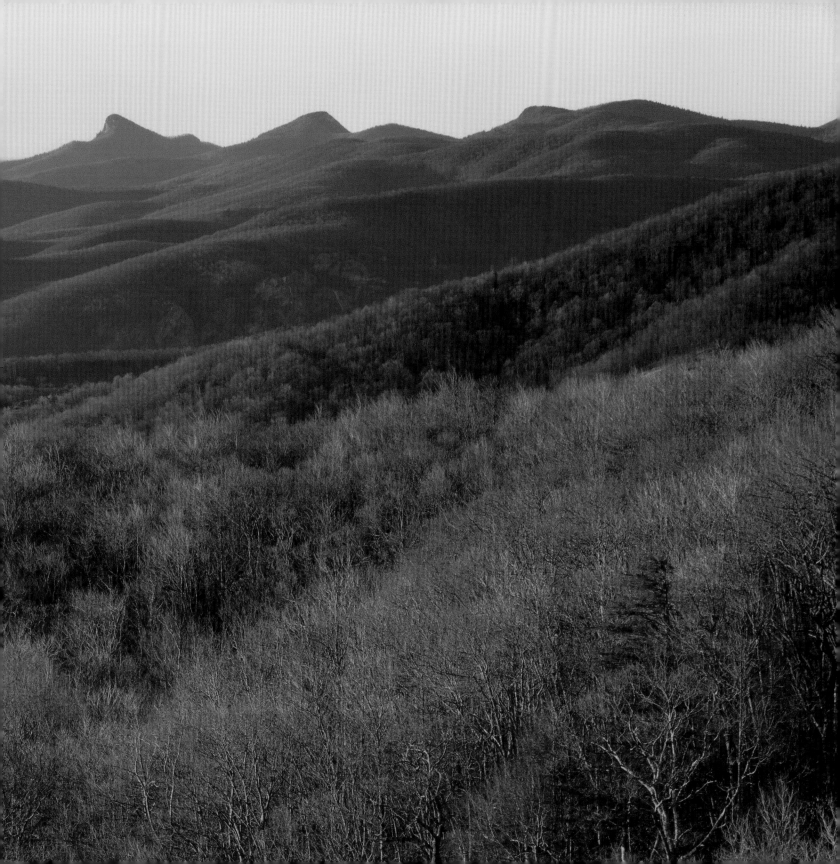

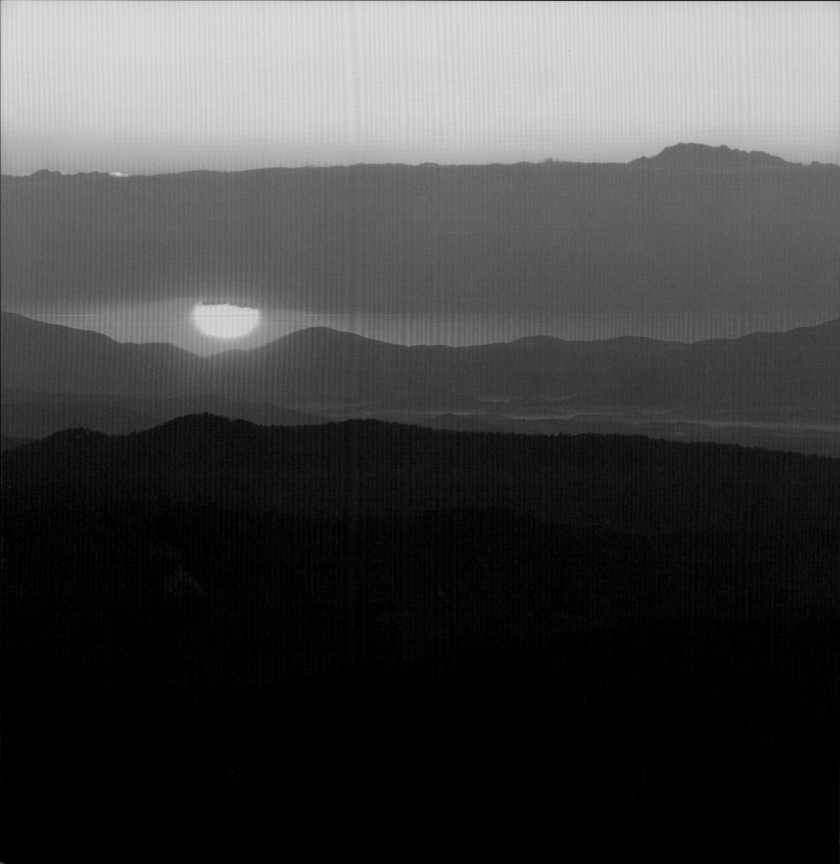

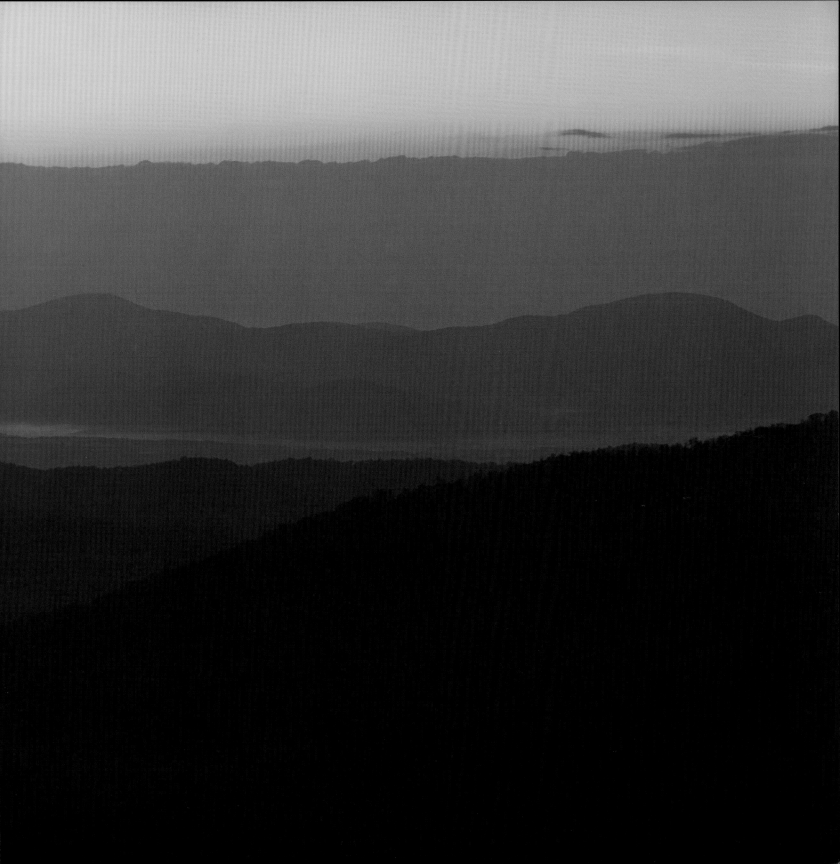

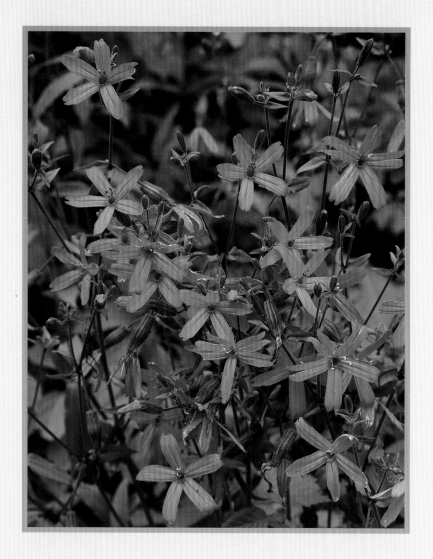

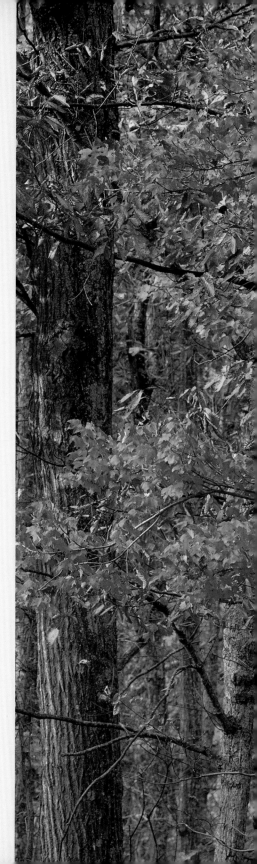

Above: Fire pink blooms in profusion in summer along the Parkway. Photo by Ian J. Plant

Right: Sugar maple in autumn, Virginia. Photo by Ian J. Plant

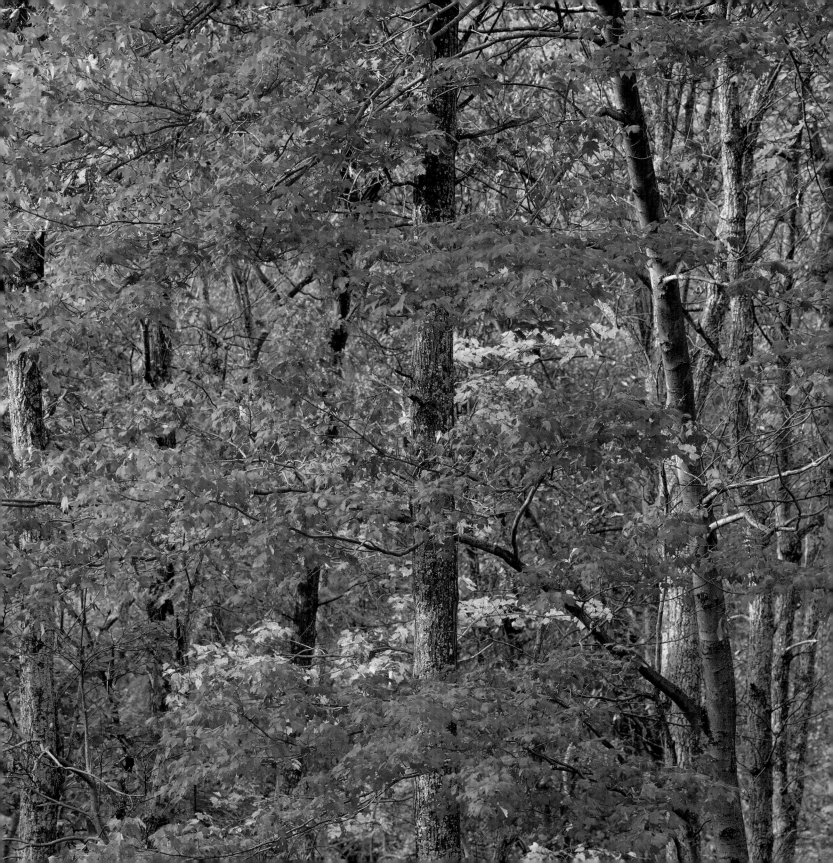

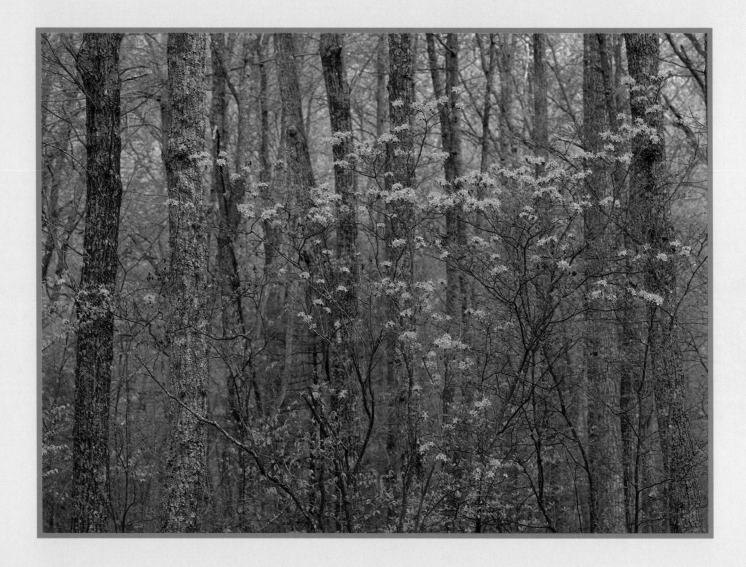

Flame azalea, along the Parkway in Virginia. Photo by Ian J. Plant

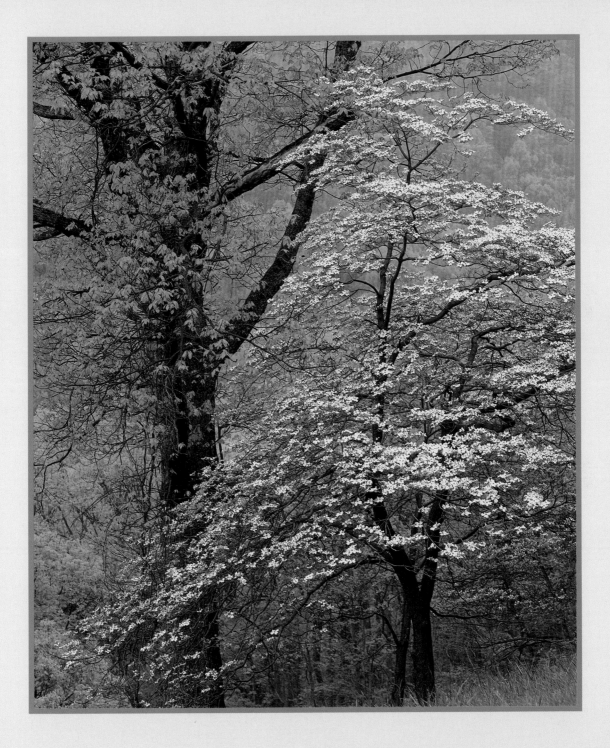

Dogwood blooms in spring, Virginia. Photo by Ian J. Plant

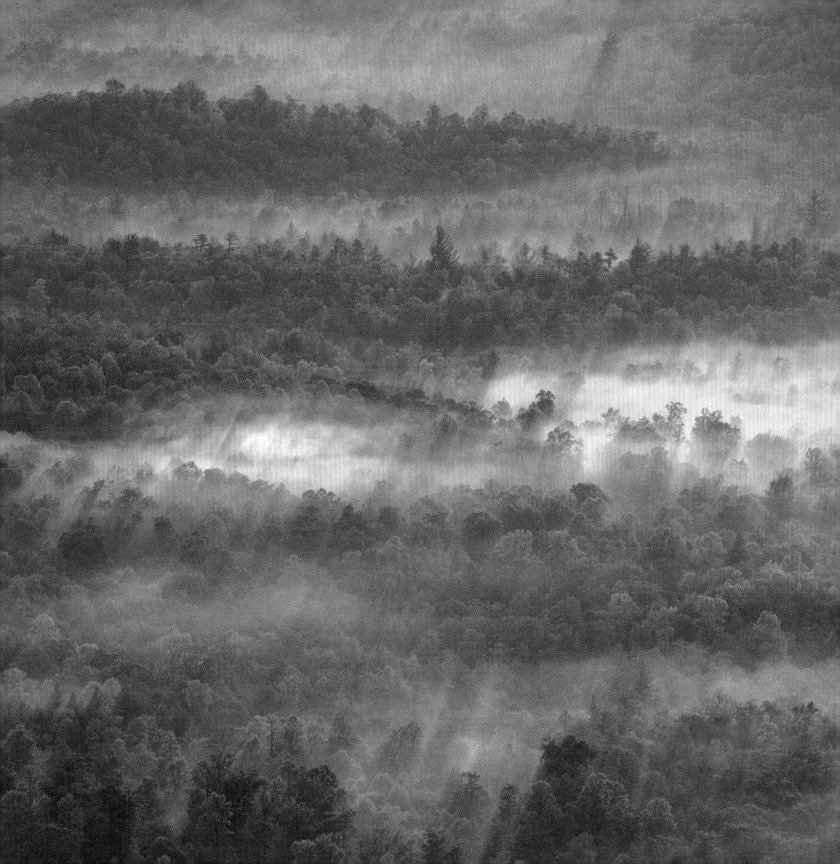

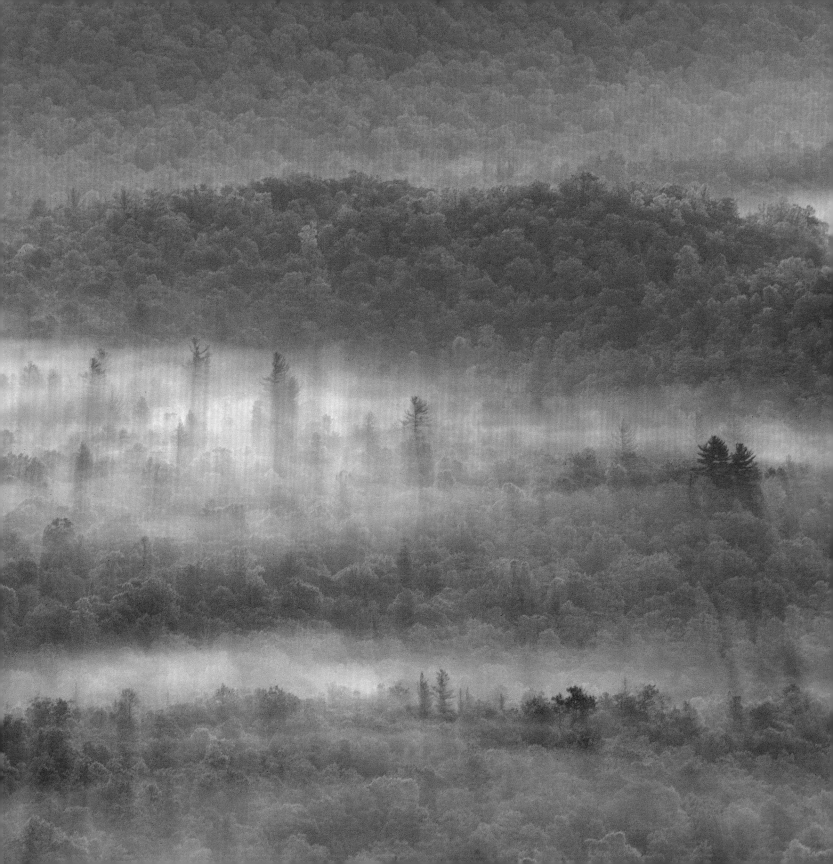

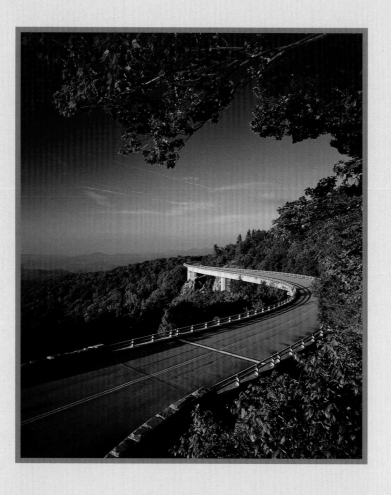

Previous page: Morning light streaks through wisps of fog in the valleys below the Parkway, North Carolina. Photo by Ian J. Plant

Above: Summer view of the Linn Cove Viaduct, North Carolina (milepost 304). Photo by Jerry D. Greer

Right: Summer wildflower garden, North Carolina. Photo by Jerry D. Greer

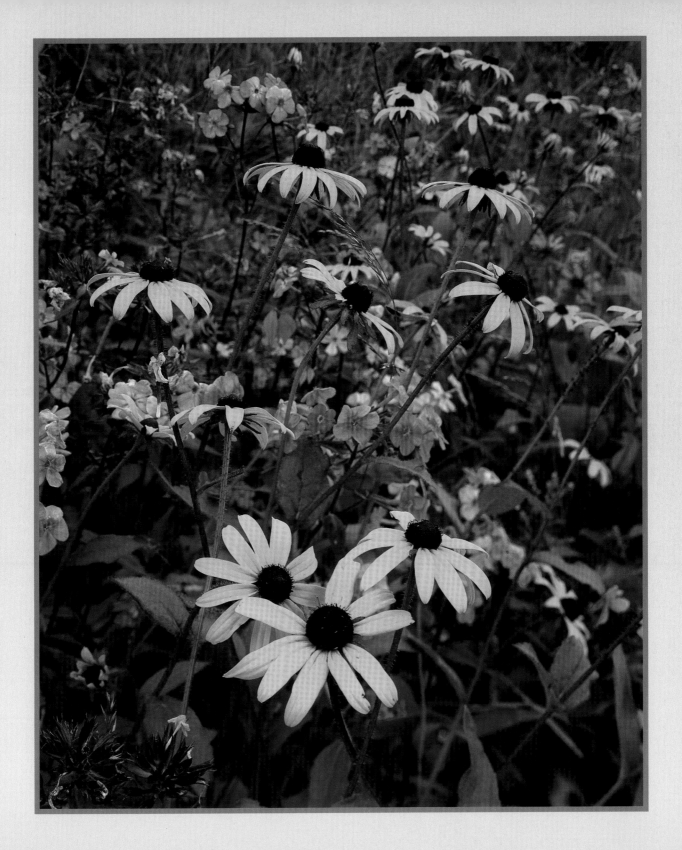

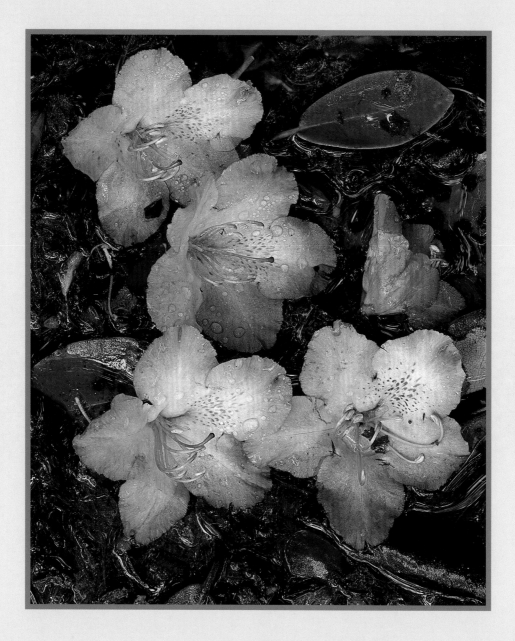

Fallen rhododendron blossoms. Photo by Ian J. Plant

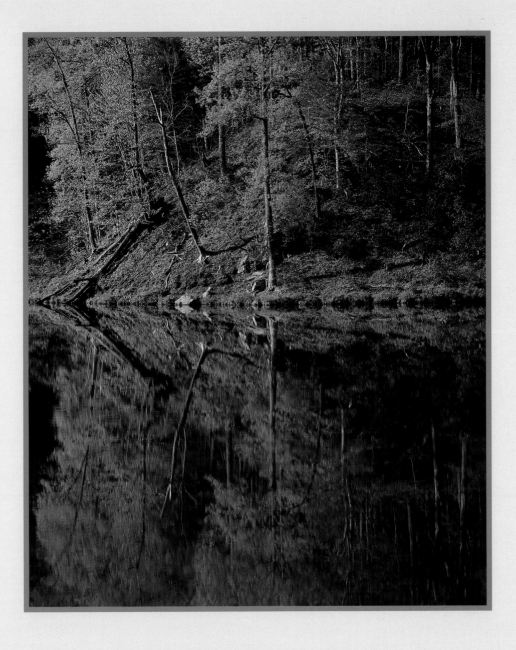

Summer reflections in Otter Lake, Virginia (milepost 63). Photo by Ian J. Plant

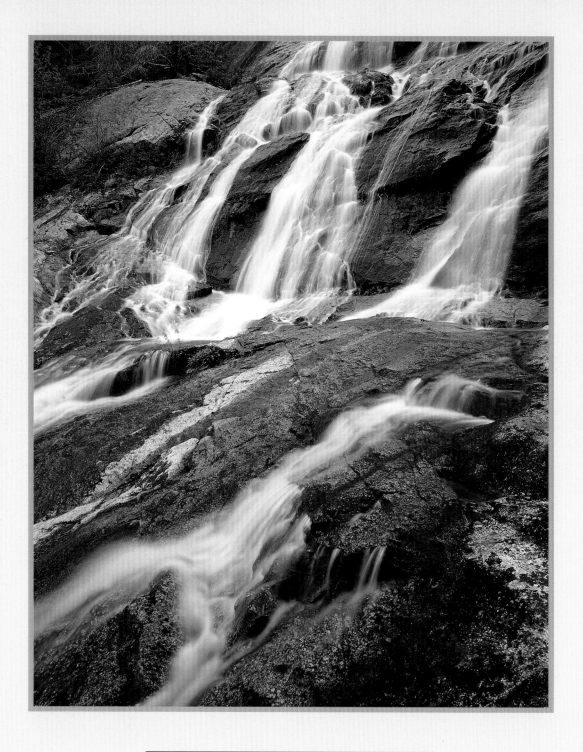

Crabtree Falls in Virginia (off the Parkway near milepost 27). Photo by Ian J. Plant

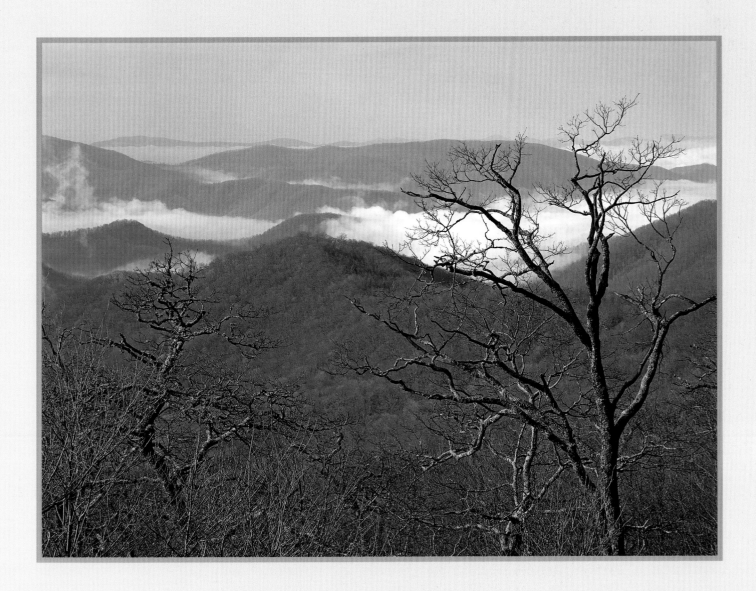

Morning fog in the valleys of the North Carolina Highlands (near milepost 450). Photo by Ian J. Plant

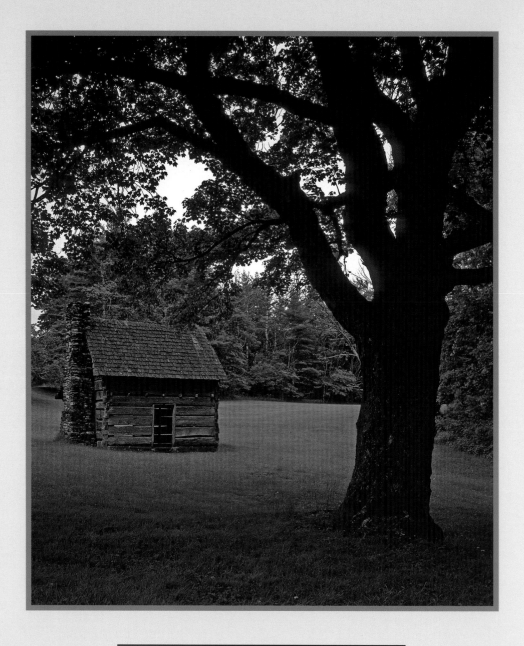

Above: Jesse Brown's log cabin (near milepost 272). Photo by Jerry D. Greer

Right: Blooming tulip tree. Photo by Jerry D. Greer

Next page: Morning mist surrounds Looking Glass Rock, North Carolina (milepost 417). Photo by Jerry D. Greer

Back cover: Sunset's golden light strikes spring trees along the Parkway in Virginia (near milepost 42).
Photo by Ian J. Plant

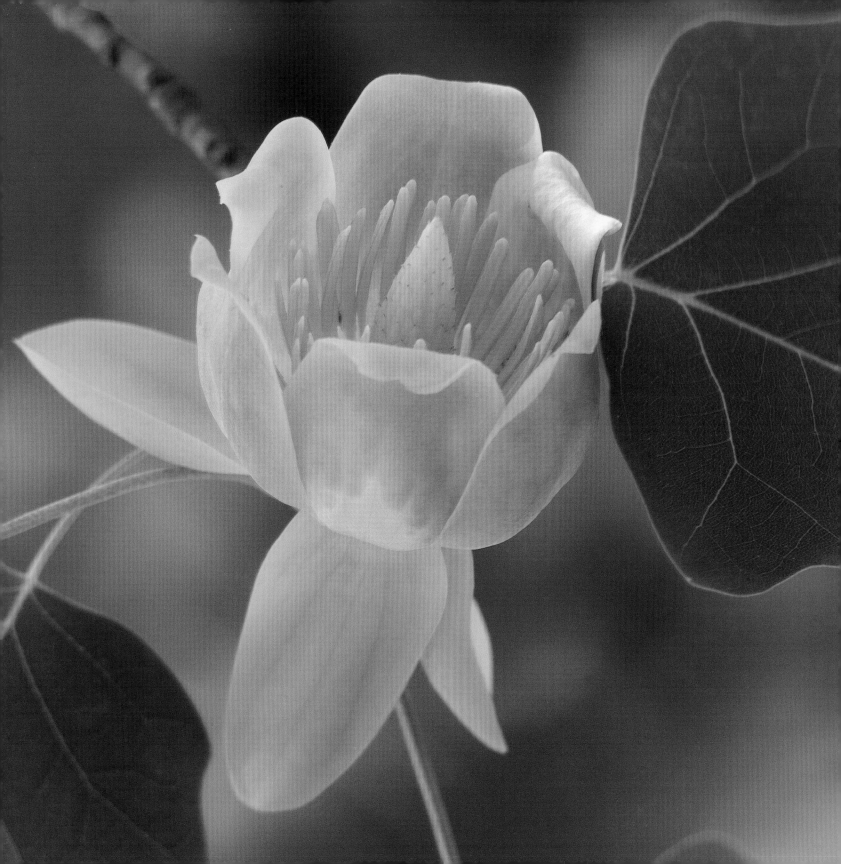

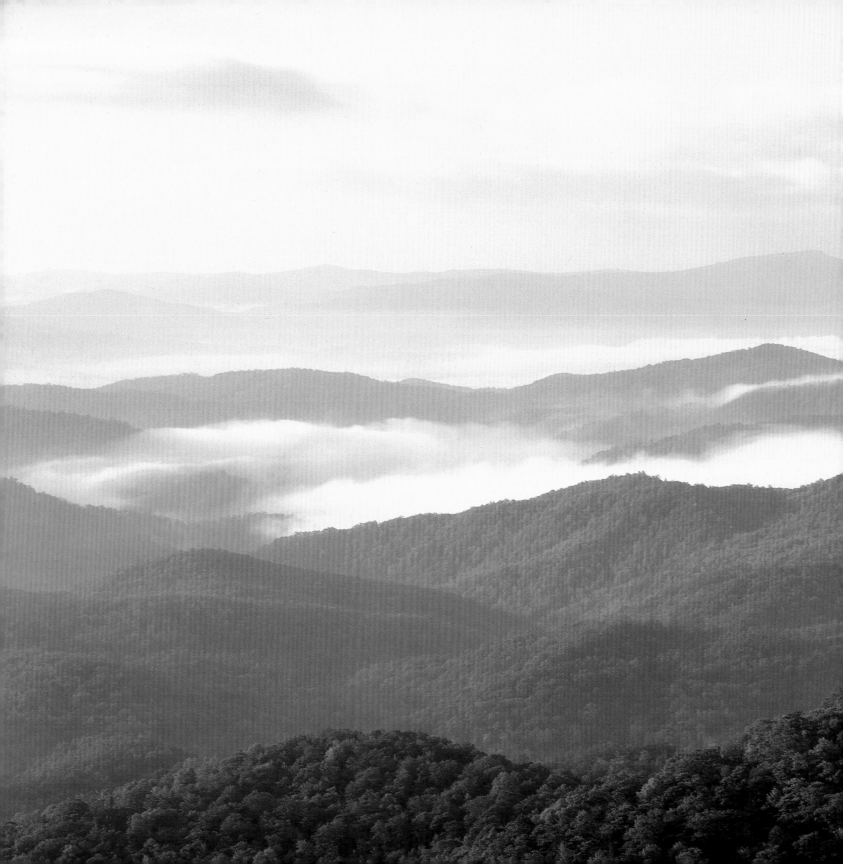

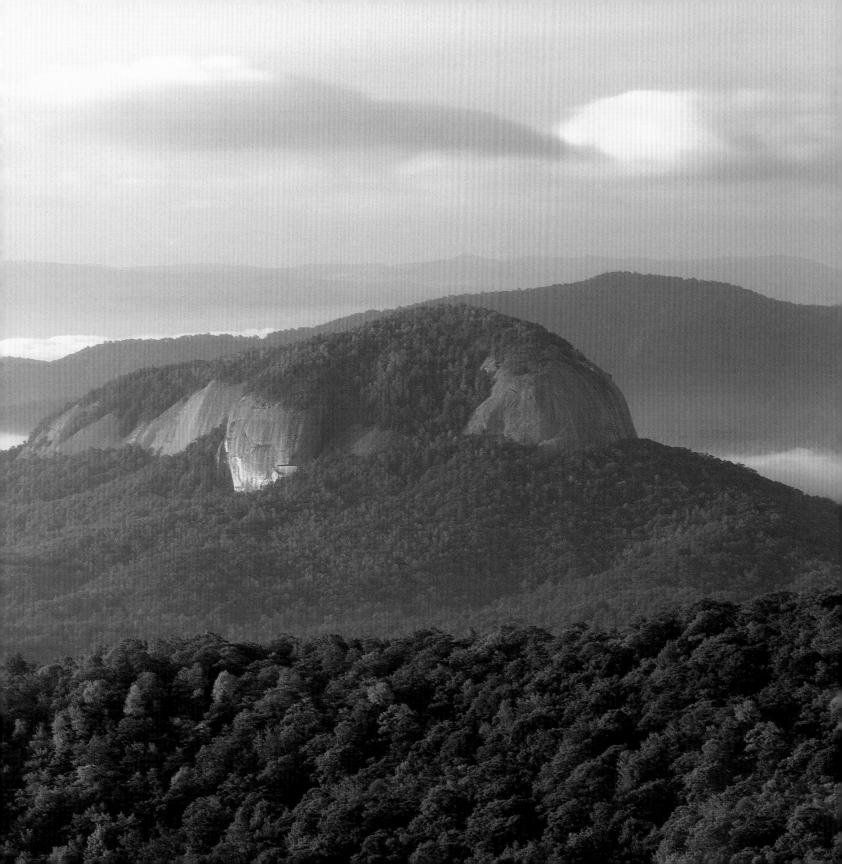

Ian J. Plant

Jerry D. Greer

About the Photographers:

Ian J. Plant has been photographing America's natural beauty for the past eight years. His work has appeared in a number of publications, including *Blue Ridge Country* and *Adirondack Life* magazines. Ian lives in Lorton, Virginia with his wife Kristin and their cat Kali. You can purchase fine art prints of Ian's images in this book from his website, **www.ipphotography.com**.

Jerry D. Greer has been photographing our natural world since 1989. His images have appeared in numerous regional and national publications, including *Backpacker*, *Blue Ridge Country*, *Appalachian Trailway News*, and *Mountain Bike* magazines. Jerry lives in Johnson City, Tennessee with his wife Angela and their dogs Garth and Mystique. You can purchase fine art prints of Jerry's images in this book from his website, **www.jerrygreerphotography.com**.

Other books from Mountain Trail Press featuring the photography of Ian and Jerry include:
Appalachia – The Southern Highlands (Jerry D. Greer)
Shenandoah Wonder and Light (Ian J. Plant)
West Virginia Wonder and Light (Ian J. Plant)
Blue Ridge Mountains – America's First Frontier (Jerry D. Greer)
Blue Ridge Mountains Scenic Wall Calendar (Jerry D. Greer)